Hirschfeld's New York

X

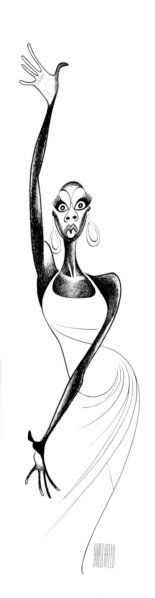

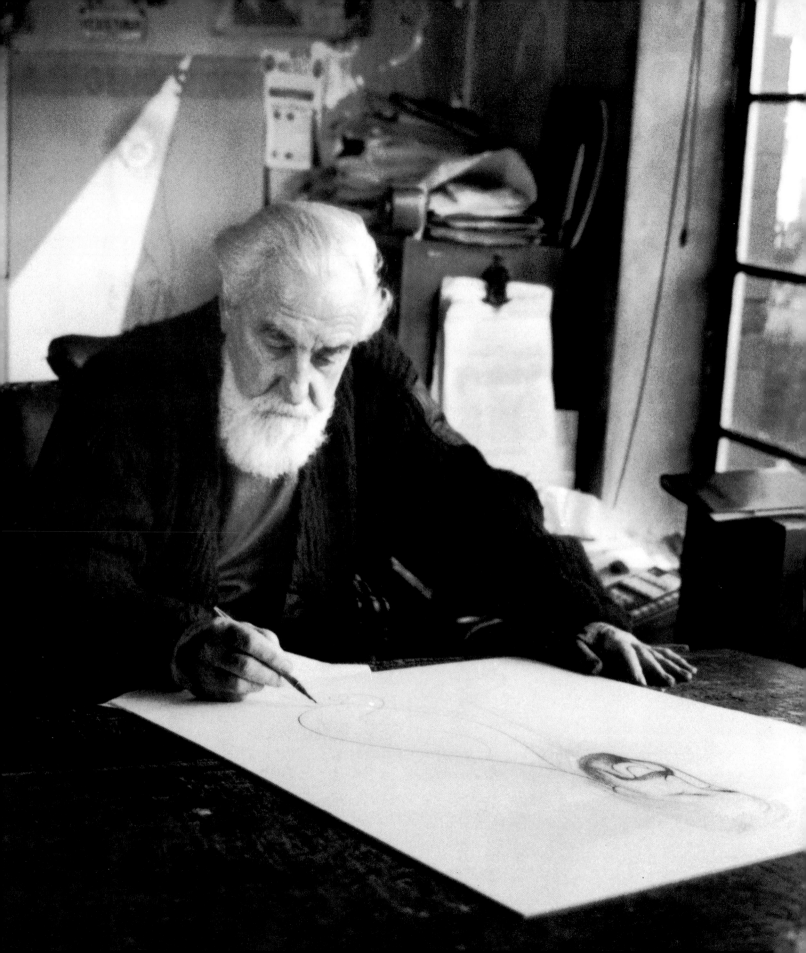

Hirschfeld's New York

Text by Clare Bell

Introduction by Frank Rich

Harry N. Abrams, Inc., Publishers

in association with the

Museum of the City of New York

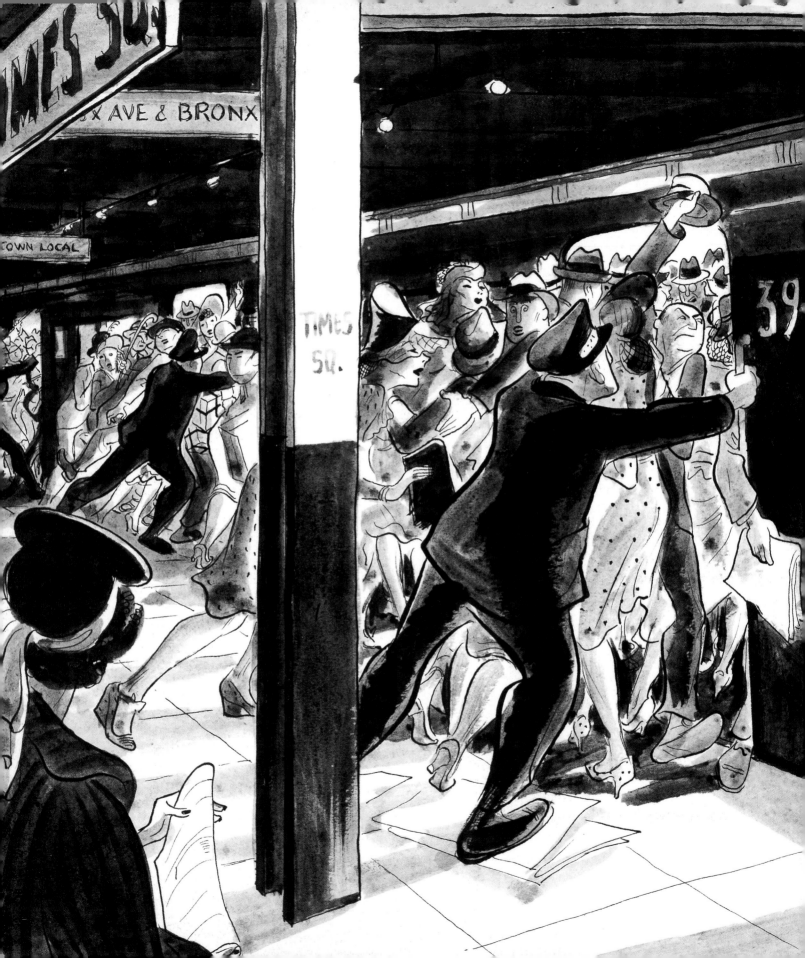

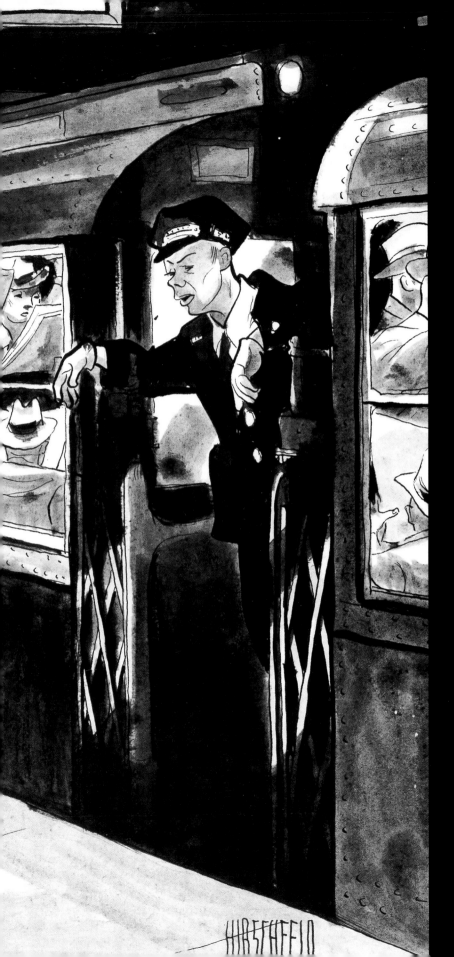

Contents

Foreword 7
Robert R. Macdonald, Director,
Museum of the City of New York

Introduction 9
Frank Rich

The Alchemy of Ink:
Hirschfeld's New York 13
Clare Bell

Notes 94

Index 95

Photo Credits 95

Acknowledgments 96

Subway Drawing from Sardine Chauffeurs And Pushers In. Published in the *New York Times Magazine.* June 30, 1940. Ink and wash on board. Collection Edwin Bacher

Al Hirschfeld is a New York City original. For more than seventy-five years this talented artist has captured the people and places of this great metropolis while he himself has been seduced by the city's vibrant creativity and energy. An hour with Al Hirschfeld is equivalent to earning a Ph.D. in *New Yorkness*. His quick wit, sparkling eyes, and warmth communicate the special magic of one who has helped define the urbanity of New York City. That stylish gift to the city emerged from his early years as a production artist for the nascent film industry and bloomed in his theatrical representations that have appeared in New York's newspapers since the 1920s.

It is fitting that the Museum of the City of New York has organized *Hirschfeld's New York,* the first major museum exhibition of the artist's work in the place he has called home for almost ninety years. The inspiration for the exhibition and the accompanying catalogue came from another quintessential New Yorker, Arthur Gelb, the former managing editor of the *New York Times* and, with his wife Barbara, the chronicler of Eugene O'Neill. Al's friends and admirers are legion. One of them, Frank Rich, in his Introduction to the catalogue, sets the stage for understanding Al Hirschfeld and his work in the context of New York City. Clare Bell, the museum's Deputy Director, organized the exhibition and provided the introductory essay, and Peter Simmons and Kassy Wilson of the museum's staff assisted in the production of the catalogue. The Henry Luce Foundation has provided financial support for the exhibition, and the museum is particularly grateful to the foundation's President, Henry Luce, II, for his encouragement.

The museum is most indebted to Al Hirschfeld and his wife, Louise Kerz. Al and Louise opened their minds, hearts, and the full range of Al's artistic creations to the Museum's exploration of the images that have become New York City icons. This exhibition and catalogue advance the Museum's seventy-eight-year mission to present the visual culture that has distinguished this place called New York, New York.

Robert R. Macdonald
Director
Museum of the City of New York

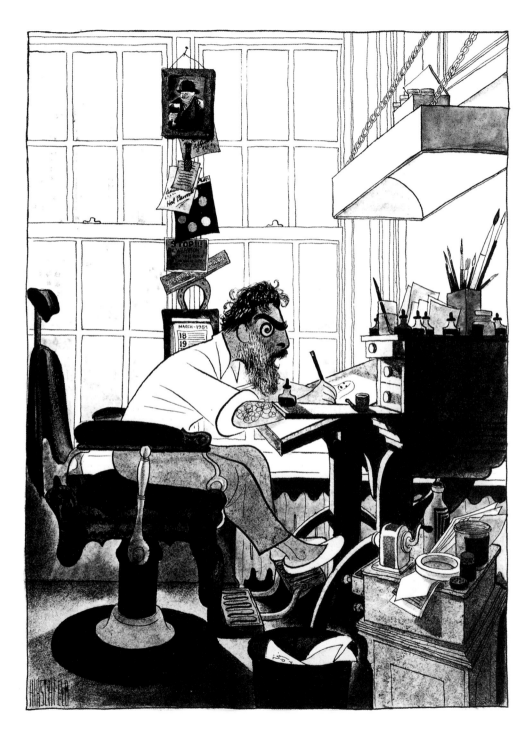

Self-Portrait (in Barber Chair). 1954. Ink on board.
Collection Joseph M. Erdelac

Introduction

When Al Hirschfeld was born in 1903, the juncture of Broadway and 42nd Street was at the heart of Long Acre Square, which was still a year away from being renamed in honor of the occupant of its first skyscraper, the *New York Times*. Most of the Broadway theaters that Hirschfeld would haunt in the decades to come were also yet to be built. As we enter the twenty-first century, that neighborhood, like so many others in a city of constant tumult, has seen so many physical and spiritual transformations—from genteel red-light district to gaudy "crossroads of the world" to grimy drug pit to corporate Disneyland—that only a dogged urban historian could keep track of them. Yet there remains one constant through all the frenetic births and deaths and resurrections: Hirschfeld's art.

Hirschfeld's extravagant pictorial portfolio isn't limited to the theater, or even to New York City, but it is hard to imagine him without New York, or New York without him. His gyrating line *is* Gotham—life plugged into an electric socket, flashing neon, open all night. Like so many of New York's brightest lights, of course, he wasn't born here. He arrived, at age twelve, from St. Louis, the same town that sent Broadway two of its other twentieth-century giants, Tennessee Williams and David Merrick. Though the Hirschfelds' first home was in the then-semirural Washington Heights, the young Al didn't linger in the sticks for long.

During World War II, long after his career had been established, Hirschfeld drew some whimsical portraits of Manhattan. In the 1940 *New York As Seen by William Saroyan*, we see the city as seen by Hirschfeld too. The skyscrapers have eyes as big and mischievous as those of the comics Jimmy Savo and Teddy Hart in his legendary prewar sketch of the Rodgers and Hart musical, *The Boys from Syracuse*. The buildings sway, surely to the sultry strains of the jazz Hirschfeld had grown fond of in Harlem, and threaten to kick up their heels like the line of chorus girls near the periphery of the picture. There's an exuberance that belongs not only to New York but also to all who love it. More sardonically, in another drawing of the time titled *Sightseers' Map of New York*, Hirschfeld lays out the Manhattan-centric worldview that the artist Saul Steinberg would famously codify on a *New Yorker* cover decades later. In Hirschfeld's cartography, Manhattan is all, with the outer boroughs, not to mention New Jersey, banished graphically to the very fringes of civilization as he knew it.

In the parade of metropolitan images assembled for *Hirschfeld's New York*, it is remarkably easy to construct a historical (and at times sociological) survey of the large nocturnal swath of the city that caught Hirschfeld's eye: speakeasies and subways, Greenwich Village boîtes and the Algonquin Round Table, the Savoy Ballroom and the Stage Door Canteen. His teeming Manhattan of the 1940s is

redolent of the war, with its signs pitching V bonds and warning of air raids. Much of this New York is gone now—some of it, such as Larue's Plush Room, only faintly remembered—and so are its inhabitants. In Hirschfeld's group portraits of opening-night swells and A-list Walter Winchell column habitués are names known now only to the most devoted connoisseurs of the city's past: Richard Maney and Robert Garland and Valentina.

But as is not the case with some of the other artists and illustrators we associate with this bygone New York—say, Reginald Marsh, or *Vanity Fair's* Miguel Covarrubias—Hirschfeld's images don't acquire a scrim of nostalgia with age. His pictures accommodate few shadows where cobwebs might grow; there is no gauzy patina of romance, and even the show-biz glamour is never so thick it could curdle into camp. A Hirschfeld vibrates and "pops," capturing a fleeting moment, and never looks back. What could be more New York? His scenes have proved lasting in part because, paradoxically enough, they capture the instant disposability of everything in his city—buildings, careers, celebrity, indeed the very newspapers in which Hirschfeld's images are printed. (Many of the publications in which his work appeared, such as the *Herald Tribune* and *Collier's*, sadly proved disposable as well.)

This is why Hirschfeld's work, like New York, is inseparable from the theater. No performance in the theater is ever repeated verbatim. Any production on Broadway could close tomorrow night. The exhilaration—and sometimes the heartbreak—of theater resides in this evanescence, and Hirschfeld is nothing if not the bard of the evanescent, capturing magic on the wing before it vanishes forever.

His career spans the entire history of Broadway as we now know it. His first published theatrical portrait—of Sacha Guitry for the *Herald Tribune*—appeared in 1926, at what remains the peak of Broadway production, with as many as nine openings a night. (Seventy-five years later, nine openings in a month would be considered a miracle.) That heyday would vanish with the Depression—and the onslaught of talking pictures—and Broadway would suffer a further steep decline with the advent of television and the rise of the suburbs after the war. At this writing, the theater district, regrouping around its unexpectedly revivified 42nd Street, has found a new and often prosperous identity, as a home of spectacles for tourists. Surely Al Hirschfeld is the only first-nighter extant who was at the New Amsterdam Theater for Florence Ziegfeld's landmark production of *Show Boat* in 1927 and back there again when the same house, restored after years of neglect, reopened with *The Lion King* at the end of the century.

Through it all, Hirschfeld's style has never changed. Though he has done classic portraits of the stars of movies and TV, it's the theater, and particularly the Broadway theater, that he was born to draw. To a large extent, the most dazzling performers on the New York stage have been outsized personalities, if not outright clowns. By and large, they are not beautiful. Their acting is often not naturalistic. (If the Method had arrived earlier and ever really conquered Broadway, it would have been a setback

for Hirschfeld's career.) Many New York stars have faltered when they've ventured into Hollywood, precisely because their acting can seem overbearing, if not unbearable, in close-up.

It's these very qualities that Hirschfeld—like Broadway's most devoted audiences—treasures and celebrates in pictures that are called caricatures by others but never by him. Indeed they aren't caricatures; the actors themselves are the caricatures, rouged up by spotlights and greasepaint, and Hirschfeld candidly captures who they are. Some of the greatest are largely forgotten now, or will soon be, and yet how they continue to entertain us in his portraits—the dour low burlesque of Ed Wynn, the eye-popping glee of Bobby Clark, the shrewd ditziness of Beatrice Lillie. Mary Martin, Ethel Merman, the Lunts, Zero Mostel—yes, there are film and video records of some of these Broadway legends, but they simply lack the dimensionality and vitality of Hirschfeld's likenesses. Mary Martin flies far more fearlessly through Hirschfeld's white space than she does as wired for the TV rendition of *Peter Pan*.

Louise Kerz, Hirschfeld's wife, has said that her husband is the "logo of the American theater," and that's true, just as the theater, for all its perennial travails, is the logo of New York. For the many New Yorkers who migrated here from somewhere else—as Hirschfeld himself did—it's this idea of New York that was the magnet. Hirschfeld took that idea and transformed it into art that, like the Statue of Liberty and the Empire State Building, is now a permanent part of the city's platonic conception of itself.

Frank Rich

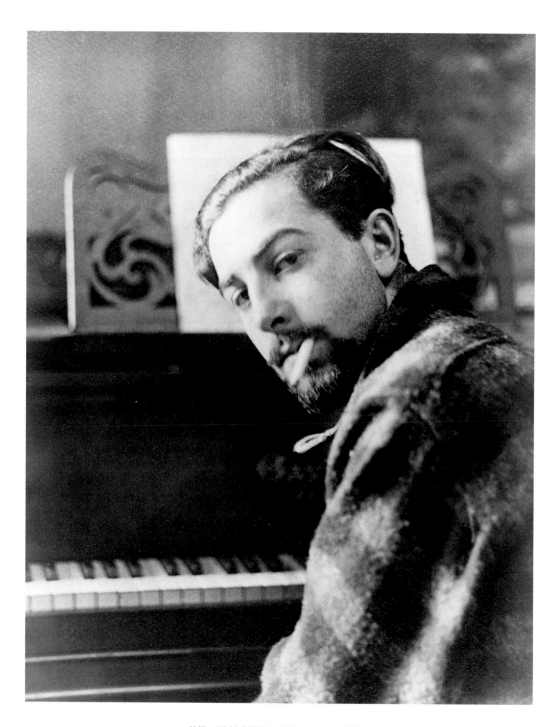

Al Hirschfeld, 598 West 177th Street. c. 1920s.

The Alchemy of Ink: Hirschfeld's New York

By Clare Bell

*Is not the caricaturist's task ... exactly the same as the classical artist's? Both see the lasting truth beneath
the surface of mere outward appearance Both try to help nature accomplish its plan.*

Annibale Carracci (1560–1609)[1]

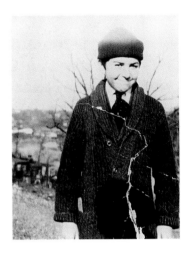

Al Hirschfeld, Washington Heights,
New York. c. 1914.

Irving Underhill. **Amsterdam Avenue,
#16, Fort George.** (no date)

Al Hirschfeld recalls arriving in New York in either 1914 or 1915 when he was about twelve years
old. The Public Library, built in 1911, was in its infancy. Grand Central Terminal had only just
replaced the old railway depot in 1913. That same year, the world's tallest edifice, the sixty-story
Woolworth Building, dominated the city's skyline. The skyscrapers of New York, epitomized by
the Chrysler and Empire State buildings, were at least sixteen years into the future. Hirschfeld
had been born in 1903 in St. Louis, Missouri. His parents, Isaac and Rebecca Hirschfeld, ran a
candy store. But the family—including Al's brothers, Milton and Alexander—left St. Louis for the
boomtown of New York City in the hope that the city could provide education and opportunities to
nurture the young artist's already demonstrated natural talent.

Hirschfeld later recalled that after arriving at Pennsylvania Station in Manhattan (the station was also a relatively new addition to the burgeoning metropolis, having only been completed
in 1910), the family boarded the Amsterdam Avenue streetcar "and went to the end of the
line, which was Fort George Park, 191st Street and St. Nicholas Avenue."[2] The area was named for
the amusement park. Trudging through the surrounding fields with all their bags, the Hirschfelds
found lodging on the second floor of a two-story frame house
on West 183rd Street in Washington Heights, an area of the
city that young Al remembered as consisting "mainly of apple
orchards."[3]

As a boy, Hirschfeld drew constantly: "It was a kind of
sickness, I suppose. Always drawing. It never occurred to me
that I could do anything else, or would want to do anything
else."[4] During World War I, Al went to grammar school at
P.S. 132 on West 183rd Street. After some years, thanks to his
mother's successful career in a department store (his father
stayed home to take care of him and his brothers), the family
was able to move into one of the new apartment buildings in
the Heights at 598 West 177th Street.

Abraham Lincoln. c. 1919. Plaster

The apartment was not far from the Polo Grounds, which had been built in 1912 and was home to New York's National League baseball team, the Giants. Hirschfeld's father was the long-standing neighborhood umpire, and the boy became an accomplished baseball player. But his zeal to draw steered him away from any professional aspirations in the sport. From one of his teammates, however, he learned about the National Academy of Design, located at West 109th Street and Amsterdam Avenue. He began evening classes shortly after with the intention of becoming a sculptor.

At the age of sixteen, Hirschfeld enrolled at the Vocational School for Boys on West 138th Street and Lenox Avenue, where he studied printing, engraving, and sculpture. He received his diploma after six months and found a job in a factory on 14th Street where he was employed carving architectural reliefs for buildings. He soon became bored by factory life and the dull repetition of artistic forms, and sought a way to apply his talent as a draftsman.

Hirschfeld's search led him to the art departments of the New York movie studios, which were bustling with activity. He began serving as an errand boy at Goldwyn Pictures. In 1921, at the age of eighteen, Hirschfeld was catapulted to the lofty position of art director at Louis J. Selznick's Selznick Pictures Corporation in Fort Lee, New Jersey, after his drawings caught the attention of Selznick's son, David O. Selznick. (David Selznick would later produce such classic films as *Gone With the Wind* and *Rebecca*.) Encouraged by Selznick Pictures to open his own production shop, Hirschfeld hired nine artists and rented space in a brownstone at 51 West 53rd Street in Manhattan, where he both lived and worked.

Hirschfeld's drawings for the motion pictures during those years could be quite elaborate and extremely ornamental in design. He often employed the flowing organic forms of the Art Nouveau style during the early 1920s, using them as background or filler for text blocks in promotions for the studio. For his more straightforward figure drawings, he typically employed the willowy style of famed American illustrator Charles Dana Gibson (1867–1944). By the turn of the twentieth century, Gibson's pen-and-ink illustrations had appeared regularly in all the popular periodicals of the day, including *The Century*, *Harper's Weekly*, and *Harper's Bazaar*. His best known creation was, in Gibson's own words, "the American girl to all the world," a woman whose independent and sophisticated demeanor signaled a welcome change from the illustrations of demure females that had been popular prior to the twentieth century. Indeed, the type became known as the "Gibson Girl."

Few illustrators before Gibson had captured such commercial interest, and Hirschfeld could not have avoided being influenced by his style and success. Yet, while Gibson mastered mood through the use of light and shadow, Hirschfeld typically eschewed strong contrasts, concentrating instead on the strength of his line.

Later, working at MGM, Hirschfeld met another illustrator, John Held, Jr., whom he later credited with having a profound impact on his art. Influenced by pre-Columbian sculpture and the

glossy black figure drawings of sixth-century Greek vases, Held turned highly stylized thin lines into literate symbols in his illustrations. He would soon go on to create one of the icons of the 1920s, the "flapper," a bob-haired sprite of tomboyish femininity who became synonymous with the Jazz Age. Held's influence—especially the finesse and clarity of his line—was immediately evident in several of Hirschfeld's early drawings of Laurel and Hardy for MGM. They remain among the most geometrically balanced caricatures of his entire oeuvre.

Along with publicity materials for new films (page 27), Hirschfeld often did portrait drawings of studio personalities. Usually created with a combination of pencil, ink, wash, and crayon, Hirschfeld's bust portraits echoed Gibson's lightness of touch and sense of romantic realism. His 1922 drawing of Myron Selznick, for example, appeared in the Selznick Pictures weekly newsletter *The Brain Exchange*. Hirschfeld employed subtle gestures of shading and outline in his portrait of Selznick to hint at the three-dimensional recesses of the face, rendering the producer's collar and bow tie in looser and more cursory marks.

While Hirschfeld's work for the motion picture studios was the work of an artist still searching for his own style, his drawings were nonetheless considerably self-assured. Hirschfeld's command of line was evident even this early in his career, and he also demonstrated an acute understanding of how to suggest volume through the juxtaposition of black and white areas, both of which characteristics would become the hallmarks of his mature work.

Life as an art director did not go smoothly for Hirschfeld. By 1923, most of New York's movie studios had gone bankrupt or abandoned the New York metropolitan area for Hollywood. Having financed the setting up of his studio and staff on the promissory notes he received from the Selznick studio, Hirschfeld followed Selznick into bankruptcy that year as well. Twenty years old and deeply in debt, he moved back home with his parents and spent the remainder of that year paying off his creditors by working at Warner Brothers Studio.

In 1924, Harlem was a cultural mecca, and Carl Van Vechten was among the ubiquitous figures on the scene. A former music critic for the *New York Times*, Van Vechten, known to his friends as "Carlo," hosted some of the era's legendary soirées at his West Side apartment. Guests included such luminaries as George Gershwin, Duke Ellington, Langston Hughes, Zora Neale Hurston, F. Scott Fitzgerald, Tallulah Bankhead, Paul Robeson,

Myron Selznick. 1922. Ink, wash, and crayon on paper

Laurel and Hardy. c. 1927. Published in MGM film publicity

and Rudolph Valentino. The mix at Van Vechten's parties gave rise to a popular Harlem story of the day: "Good morning, Mrs. Astor," says a porter at Grand Central station. "How do you know my name, young man?" "Why, ma'am," the porter explains, "I met you last weekend at Carl Van Vechten's."[5]

At one such evening Van Vechten introduced Hirschfeld to Miguel Covarrubias, a Mexican painter and illustrator who had arrived in New York from his native Mexico City the previous year. The two young men soon became fast friends, eventually sharing a studio at 110 West 42nd Street. While it is clear from Hirschfeld's involvement with publicity for early motion pictures that he was not a stranger to the art of caricature, Covarrubias had already secured his reputation in the genre, contributing illustrations to major magazines such as *Vanity Fair* and the *New Yorker*. Evident in sketches that Hirschfeld made of his friend at the time (page 19) is his own interest in character drawing. In Hirschfeld's depiction, Covarrubias appears at his easel, passionately absorbed in his drawing. To convey the intensity of the moment, Hirschfeld rendered Covarrubias's brows as a singular arabesque, his eyes as corkscrews. Hirschfeld would continue to employ such reductive but dramatic devices in the years that followed.

Covarrubias's work was certainly an inspiration to Hirschfeld, and the two often shared subject matter and a penchant for caricaturing their contemporaries.[6] Covarrubias's *First Night—Entr'acte,* for instance, published in *Vanity Fair* in October 1930 (page 17), includes many of his and Hirschfeld's New York cronies: budding playwright George S. Kaufman, theater critic Alexander Woollcott, Van Vechten, and many others. A comparison, however, of Covarrubias's style to a later triptych by Hirschfeld from 1958, *Broadway First Nighters* (page 60–61), reveals profound differences in their approaches. Where Covarrubias sculpted his personalities from prominent shadows, Hirschfeld achieved his with line alone. Their sense of space is markedly different as well. In Covarrubias' rendering of the crowd, one gets the sense of dramatic recessive depth, yet little or no space exists around each figure. In contrast, Hirschfeld was able to achieve a sense of space not only behind his figures but also around them by keeping the scale of the foreground figures roughly the same.

In 1925, at the age of twenty-two, in the midst of New York's economic boom, when industrial growth had forever changed the city's mood and appearance, Hirschfeld left for Paris. Like many young artists of his day, he was beckoned by the allure of an expatriate's life in the City of Light, where modern art was being born. Thanks to the generosity of his uncle, Hirschfeld purchased a ticket on a passenger liner, the *De Gasse,* and set sail for Europe with $500 pinned inside his jacket.

For the next year and a half, Hirschfeld painted. In Paris, he encountered some of modern art's most influential people—Pablo Picasso, Gertrude Stein, and numerous others. By then, he had also bought a lithographic press and began printmaking in earnest. When he could no longer stand the cold conditions of his Paris studio on the rue Vavin, Hirschfeld traveled south. He went first to Madrid, next to Seville and Cadiz, then through the North African cities of Tangier, Algiers,

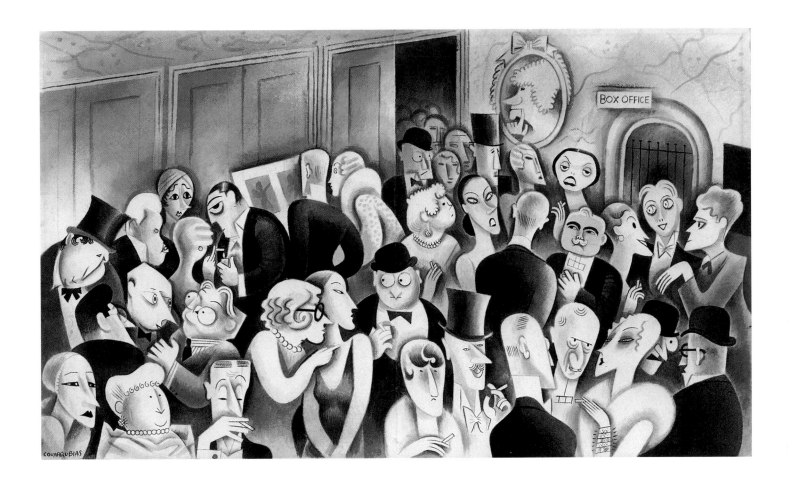

and Tunis, through Carthage and Sicily, and finally up through Italy and back to Paris. In North Africa Hirschfeld produced his first truly noteworthy *plein air* watercolors.

In April 1926, Hirschfeld exhibited his watercolors for the first time in a small show in Paris. Wrote one critic, "Many Americans should see these pictures; it is [sic] an event when we produce a new artist and especially when he is a young man with such glorious promise."[7] Shortly thereafter, Hirschfeld decided to return to New York.

It was then that Hirschfeld met Florence Allyn (née Hobby), a chorus girl who, according to the artist, "was the granddaughter of a fellow by the name of Coney, who founded Coney Island."[8] In a sketchbook Hirschfeld kept during the years after his return to New York, there is a rendering of Flo sleeping in his studio at 3 Sheridan Square, then considered the Times Square of Greenwich Village (page 18). More responsive to shade than outline, the drawing bears the imprint of the contemplative and saturated watercolors he had made during his North African travels. Other

Miguel Covarrubias. **First Night - Entr'acte.** (Among those pictured are: Heywood Broun, George S. Kaufman, Marc Connelly, Alexander Woollcott, Carl Van Vechten, Fania Marinoff, Gloria Swanson, Katherine Cornell, Otto Kahn). Published in *Vanity Fair*. October 1930. Ink and wash on board. Library of Congress Collection.

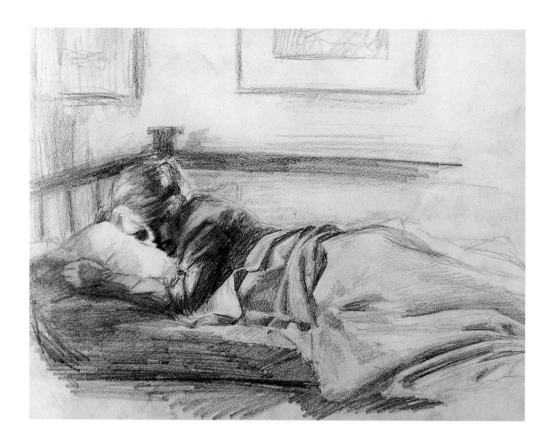

[Untitled] (Flo). From Paris/New York sketchbook 1926. Pencil on paper. Collection the artist

sketches from that year, however, reveal an artist wrestling with a variety of different styles, often on the same page (page 19).

In December 1926, the course that Hirschfeld had plotted for himself in the fine arts abruptly changed with a sketch he did in the dark on the back of a program while attending the American debut of French actor Sacha Guitry. His drawing so engaged his companion for the evening, press agent Richard Maney, that he convinced Hirschfeld to create a clean copy, which Maney then delivered to the *New York Herald Tribune*. Hirschfeld's drawing of Guitry was published on the front page of the drama section the following Sunday. Other theatrical assignments soon followed: for the *Tribune*, the *World*, the *Telegram*, the *Telegraph*, the *Brooklyn Eagle*, and *New York Amusements*. By the age of twenty-three, Hirschfeld had become an established illustrator.

In January 1928, Hirschfeld created his first caricature for the *New York Times*, a depiction of the Scottish vaudevillian Harry Lauder (page 21). An amalgamation of patterning, staunch black line, and interlocking forms, Hirschfeld's drawing of Lauder was reminiscent of the abstract figurative work of artists associated with the Russian avant-garde. Lauder's awkward, muscular physicality bore little resemblance to the trimmed-down linear representation of Guitry. Nevertheless, it is clear from Hirschfeld's drawing of Lauder that the artist was intent on moving

beyond realism into the abstract nature of line. "There is something almost religious in the pure magic of a line capturing a human character," Hirschfeld once reminisced of his early years when he and Covarrubias worked side by side.[9] By the end of the Roaring Twenties, Hirschfeld's commissioned pieces had begun to appear in print with the added designation, "An Al Hirschfeld Caricature." Nevertheless, Hirschfeld never considered exhibiting his graphic works because, as he noted, "…everybody took it very lightly, except myself."[10]

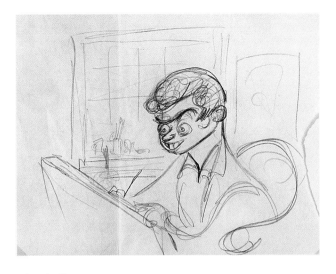

On July 13, 1928, Hirschfeld and Flo Allyn were married, and once again Hirschfeld left New York, this time on assignment for the *Tribune* to cover theater in Russia. Eleven years after the October Revolution had taken place in Russia, Hirschfeld set out to capture the energy, ideas, and upheavals of Communism, at least as they were reflected in the theater. In the New York that Hirschfeld was leaving behind it was the heyday of skyscraper building and the Art Deco style was in vogue. Perhaps as a reflection of Art Deco's influence on his style, Hirschfeld's illustrations of Moscow's theater elite were decidedly more angular and his line more finely tuned and elegant than in his previous work. On the other hand, the lithographs depicting street scenes of Russian people that he produced after his return home reveal a style altogether different from his illustrations. By the late 1920s, Hirschfeld was an accomplished printmaker, and his experiences in Russia crystallized his understanding that the printed form was a powerful tool of social change and progress.

Miguel Covarrubias (at 110 West 42nd Street Studio). 1924. Pencil on paper. Collection the artist

[Untitled] (Rodie Davenport, Dick Kennedy). 1925–26. From Paris/New York sketchbook. Pencil on paper. Collection the artist

Hirschfeld decided to stay in Europe after his Russian assignment, and his travels eventually took him to Persia, where he produced more watercolors, as he did in other places such as Baghdad. After a return to Paris, he occasionally sent back sketches to the *Tribune*, mostly of American nightclub entertainers who appeared at the Ambassadeur. "But there was no American theater there."[11] In late 1928, Hirschfeld had another exhibition of twenty-five watercolors at gallery Havard Frères on the Boulevard Montparnasse in Paris. "They are the work of a capable and sensitive artist, who deserves being taken seriously," wrote one reviewer.[12] "Remarkable studies of human physiognomy," wrote another.[13]

In 1929, Hirschfeld had his first show of paintings and drawings in New York at the Newhouse Galleries at 11 East 57th Street. By Hirschfeld's own account, he was still "toying with the unrewarding chore of copying nature—in oil and watercolor—and establishing [my]self as a serious painter."[14] Some in show business admonished him for such lofty aspirations. A front-page story in *Variety* from October 23, 1929, read:

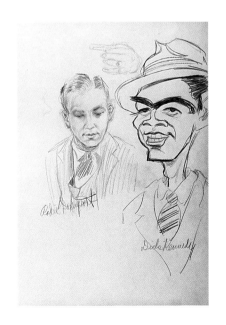

Broadway's best known youthful beard-wearer is Al Herschfeld [sic], who does art work for theatres and film companies. Al admits that before he got the beard idea he struggled without success, couldn't make an impression and was generally discouraged. But once his boyish face became a landscape he began to click, to get commissions. People asked who he was, noticed him with interest and found him talented.[15]

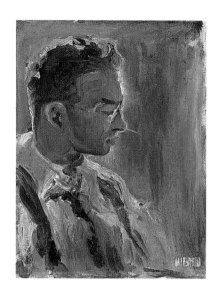

Gordon Kahn. c. 1922. Oil on canvas. Collection Mr. and Mrs. Robert P. Schwartz

Six days after the article appeared, the nation's stock markets crashed, and with Black Tuesday eight straight years of American economic boom came to an abrupt end. Not long after, Hirschfeld sued *Variety* for defamation of character. He eventually won his case, but no monetary compensation.

In 1931, Hirschfeld left New York again for the West Coast, where he and Flo boarded a ship to Tahiti. Tahiti, however, failed to provide the artist with the exotic challenges he sought, and he decided to head to Bali on the advice of Covarrubias, who had recently sojourned there. Hirschfeld stayed in Bali for nine months and returned from his travels in the South Sea Islands and East Indies having completed thirty-eight paintings. Hirschfeld credits the elongated figures, high stylization, humor, design, and sculptural and plastic quality of Balinese art as among his most lasting influences.

Returning to New York in June 1932, Hirschfeld began his first book, *Manhattan Oases, New York's 1932 Speak-Easies* (pages 28–30). The Volstead Act, the eighteenth amendment to the Constitution, had gone into effect on January 16, 1920, forbidding the manufacture, sale, and transport of alcoholic beverages. Few, including the police, enforced the federal regulations, at least in New York City, and the underground life of drinking and entertainment offered Hirschfeld a rich panorama of social scenes. He employed a variety of styles to capture the humanity and humor he saw in the smoky interiors, and among the bartenders and patrons of Gotham's notorious speakeasies. Works such as *Mike's Barman Ralph* (page 28), Hirschfeld's observation of the employees of one watering hole located on Seventh Avenue in the 40s, includes skillfully modeled faces in three-quarter view juxtaposed with figures whose faces are created from flat planes in profile. Others, such as *O'Leary* (page 30), are conjured from raw and brittle lines that perfectly justified Gordon Kahn's accompanying commentary that this was a bar, "Not for the squeamish, in stomach or nostril."[16] In still other drawings, such as *The Mansion Barman Eddie* (page 30), Hirschfeld pushed so far beyond naturalism that his figures at the bar appear more like apparitions than real people. The drawings foreshadow many of the signature elements that typify Hirschfeld's later work, such as using tight corkscrews to denote curly hair, spirals for curled fingers, oversized hands, and the use of smaller figures in motion to animate the composition.

During the height of the Great Depression, Hirschfeld began to depict New York City in earnest. Although unemployment was rampant, poverty staggering, and soup kitchens abundant, building throughout the city was at an all time high. The public works projects begun under President Roosevelt's New Deal administration in 1933 included a staggering amount of new civic development in the form of widened highways and new parks, schools, and bridges throughout the country. New York City underwent the most rapid expansion thanks to the ingenuity and charisma of such figures as Mayor Fiorello H. La Guardia (page 50), public works impresario and Parks Commissioner Robert Moses (page 44), and New York's former governor Alfred Smith (page 31).

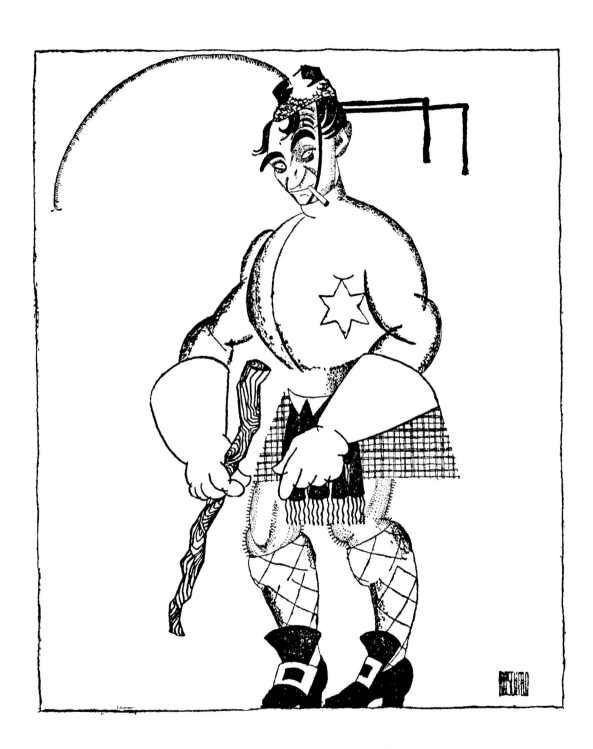

Harry Lauder. Published in the *New York Times*. January 29, 1928. Ink on board

The Works Progress Administration (WPA) was established in 1935 to consolidate the government's relief programs. By 1936, New York City was receiving one-seventh of the WPA allotment for the entire country.[17] The Federal Art Project (FAP), a subsidiary of the WPA, ensured that the arts were also funded. Unlike many artists of his generation, Hirschfeld did not have to rely on the FAP for work, thanks to a steady stream of commissions from newspapers and periodicals. Reflecting New York's modernization and its pageantry, Hirschfeld contributed his own blueprints of the city, adding to the well-established genre of cartoon cartography (page 34) in a number of pieces he did for the *New York Times*. Despite their clownish bravado, Hirschfeld's drawings make overt the violence and overcrowding that underscored progress and tourism in the city during the heyday of the La Guardia years.

By 1938, the House of Representatives in Washington had established a Committee on Un-American Activities, formed to combat Communism and its perceived threat to the nation. Any artwork that could be construed as subversive was under suspicion, most especially the abstract art of the European circles in which Hirschfeld had traveled. Although Hirschfeld continued to remain loyal to the figure, he was by no means indifferent to creating work of social protest. His stint as a correspondent in Russia ten years earlier had only solidified his political and ideological resolve, not to mention his keen awareness of the power of print to inform and arouse an audience. He contributed numerous drawings to such dissenting left-wing forums as New York's *New Masses* and satirical magazines such as the short-lived *Americana*. During these years, when he was back and forth between Europe and New York, Hirschfeld also did a number of lithographs. Highly personal in their observations of the plight of everyday people, his viscous application of ink seemed a far cry from the crisp lines of his commissioned work on the theater. Hirschfeld's "social" lithographs never made it into print at the *Times* because lithography, much like abstract art and its European roots, was considered "Communist art."[18]

On April 30, 1939, the New York World's Fair (page 36) ushered in a renewed sense of optimism in the city. The future was at hand, or so screamed the technological exhibits and the wonders and amusements on view at the fairgrounds in Flushing Meadows, Queens. By then, however, the Great Depression had wreaked havoc throughout the metropolitan area and beyond. The world was a more complex place than it had been, and with war on the horizon in Europe it was even more so.

In 1941, Hirschfeld compiled a new book of line drawings along with colored lithographs entitled *Harlem as Seen by Hirschfeld* (pages 37–39). The area was no longer the Harlem of Hirschfeld's 1920s heyday years, and he seized on the blend of African and American character of its locale and occupants, alternating his illustrations between geometric black line drawings and more limber, vibrantly colored lithographs. The effect was a book whose artworks shifted between restrained expression and exultation.

Hirschfeld's portrait studies from this period are largely of unknown individuals, contrasting with the celebrity portraits that later became his specialty. Drawn from close-up, Hirschfeld's subjects are unaware of being watched. His works are voyeuristic but not merely documentary, in motion without being frenetic. In the foreword for *Harlem*, playwright-novelist William Saroyan wrote "[Hirschfeld's] culture is unobtrusive but all over the place, and his innocence holds its hand."[19]

By the early 1940s, many among Europe's avant-garde had fled the Nazi horrors to seek refuge in America, and in a few short years the center of the art world shifted from Paris to New York City. American art was soon consumed with Surrealism's emphasis on automatic thought and gesture. Such bravado led to the formation of a loosely defined New York School, centered around a social gathering place called The Club at 58 West 10th Street in Greenwich Village. Hirschfeld was no stranger to the Village during the early 1940s having, in his own words, "given some of the best years of my life to living in Village studios where earlier inspirations were fried out of me underneath the unventilated skylights."[20]

The new freedom and energy of American art initiated and fostered by the city's rapid progress also found its way into Hirschfeld's work. Looming skyscrapers became a familiar motif in many of his New York depictions during this period, at the same time that his compositions took on a more complex panoramic structure. Works such as *New York as Seen by William Saroyan,* 1940, and *What's the Matter with New York?,* 1943 (pages 44 and 45), were cinematic in scope and included both ordinary people on the street and more recognizable faces on the New York scene. By 1944, abstract artists had gradually divided themselves into those who espoused vigorous brushstrokes and those who were proponents of flat planes of color. "Art is no longer a sacred word, success no longer a disgrace. A sort of lifeless mumble of revolt still goes on, but the theatrics of bohemianism are dimming," wrote Hirschfeld.[21]

By then, Hirschfeld was living in a penthouse studio atop the Osborne Apartment House at 205 West 57th Street (page 36). His quick-witted line and careful observation of details brought to life New York's skyline, subways, rooftops, clubs, cafeterias, canteens, and dance halls, as well as the hustle and bustle of Broadway opening nights.

In 1943, Hirschfeld divorced his first wife, Flo, and married German actress Dolly Haas. The marriage lasted until her death in 1994. (In 1996, he married theater historian Louise Kerz.) Daughter Nina was born in 1945, and in 1948 the family moved to East 95th Street. With Nina's birth came Hirschfeld's best known conceit—hiding her name in the crannies and folds of his subject's physiognomy or attire, often more than once.

Also in 1943, the editors at the *New York Times,* frustrated over seeing Hirschfeld's illustrations, often for the same play, in the pages of their newspaper and those of their competitors, offered Hirschfeld an exclusive contract.

By the late 1950s, American painting had witnessed the swell and ebb of Abstract Expressionism, typified in the works of such artists as Jackson Pollock, with his virtuoso brushwork, allover compositional structure, and dedication to the universal notion of the sublime. Hirschfeld's use of intricate patterning also reached its apogee in 1950 with such pieces as *Guys and Dolls* (page 80). By the following year, Hirschfeld had more or less abandoned ornament and shade to fill out his scenes and opted instead for bolder directed line to create his personages. His illustrations for *The Vicious Circle,* Mary Harriman's 1951 book about the group of New York writers who used to meet for lunch at the Algonquin Hotel, have a light-hearted caustic quality much like that of the wits themselves (pages 54 and 55).

Duality, much like simultaneity, was another device often used by Hirschfeld at this time. He occasionally employed the graphic device seen sometimes on playing cards to create mirror images of subjects, as in his magazine cover drawing of Frank Costello, one of New York's notorious gangsters, for *The American Mercury* (page 51). The alchemy achieved by Hirschfeld's pen is never more apparent than in works such as his 1951 linked images of the heads of writers George S. Kaufman and Edna Ferber (page 54). Earlier, in 1938, Hirschfeld had achieved a similar synthesis with performers Teddy Hart and Jimmy Savo in his drawing based on Rodgers and Hart's musical comedy *The Boys from Syracuse.* Although Hirschfeld's drawing is not purely naturalistic, he insists that he does not exaggerate, preferring to allow line to metamorphose his figures. By contrast, he considered Walt Disney's Snow White an "anatomic automaton." Hirschfeld wrote in 1938, "there is nothing to be gained by such perfect facsimile."[22] The character's presentation is Hirschfeld's idea of anti-line drawing, the result of rubberstamping, not living line.

Throughout the Great Depression, World War II, and the Cold War, Hirschfeld observed the city, although he usually did so while seated in the darkened rows of Broadway's stages. "I think theater reflects life much more than papers, magazines," he once told an interviewer. "For instance, all during the Depression years if you'd pick up a copy of *The Saturday Evening Post* in the years from '29 to '32, you'd never know there was a depression in this country."[23] Theater reflected the experience of Hirschfeld's life, and he, in turn, reflected it back onto the page. From the anonymity of Sidney Kingsley's 1935 drama, *Dead End*, to the vagabond years reflected in Eugene O'Neill's 1946 masterpiece, *The Iceman Cometh* (page 81), to the street gangs and social insights of Leonard Bernstein and Stephen Sondheim's 1957 *West Side Story*, a musical version of *Romeo and Juliet* (page 82), Hirschfeld captured the triumphs of the American theater. But he also gave us a mirror with which we could experience the palpable energy and verve of New York that has been the inspiration for so many artists, writers, and musicians in the twentieth century.

Hirschfeld reported on many behind-the-scenes activities as well (page 79). In all his works on the theater, for movies, or about television, Hirschfeld was not only depicting the reality of the play but also the reality of its staging. The quotidian realities of life are always apparent

in Hirschfeld's work, moving his drawings beyond the conventions of artifice into the realm of experience.

Beginning in the 1960s, Hirschfeld moved steadfastly in the direction of simplifying and refining his application of line. American art at the same time gave birth to Pop Art and the grids and limited compositions of Minimalism. In New York and around the world, social conditions ran the gamut from revolt to ideological indifference. And a new host of personalities came on the cultural front, playing roles that defied and challenged conventions. Actors such as Jack Lemmon (pages 85 and 86) appeared regularly in Hirschfeld's work, as did New York's new crop of producers, performers, and writers such as Joe Papp and Woody Allen (pages 75, 86). They joined the ranks of Hirschfeld's stable of caricatures, as Eugene O'Neill and Arthur Miller (pages 74, 76) had done before them. The 1960s and '70s also witnessed a resurgence of films made in or about New York. While dedicated to the theater, Hirschfeld continued to include movies and television in his field of view, reflecting the work of filmmakers who depicted the city beyond the island of Manhattan and into the lives of the working class in the other boroughs (page 90).

Never an artist to dwell on specific details, Hirschfeld could nevertheless be painstaking in the amount of information he included in his drawings, whether it was faces jammed up against each other in a dance hall (page 47) or marauders storming the fortresses of Wall Street (page 46). Those early panoramas contained the antecedents of Hirschfeld's unique brand of simultaneous activity, which he would later employ to grand effect in theatrical works such as *Jumbo* in 1935 and culminating in later pieces such as his 1957 illustration of the Broadway musical *West Side Story* (page 82). The same effect also animated his drawing for 1989's *Jerome Robbins' Broadway* (page 88), and in 1998 his drawing for *Rent* (page 89). More Mannerist than Baroque in his style, Hirschfeld has long had a penchant for interlacing movement and creating cylindrical rather than flat compositions.

Since the 1980s, Hirschfeld has displayed a decided detachment in his attempt to connect the parts that make a whole (page 1). His line is less dense and more sinewy than before. Confidence steers its course, and he begins to leave the white of his paper wide open. The legs and arms of Hirschfeld's figures are conveyed with the most minimal yet curvaceous of lines, as if he's substituted calligraphy for flesh and bone (page 68–71). Gone is the girth and musculature hinted at in 1928 in his first rendition of Harry Lauder for the *Times*. Now the skillfully guided arabesques and the pure white of his backgrounds fuse the image and the idea into an inseparable whole. The sheer unbridled motion of his pen, coupled with his uncanny ability to position his lines in just the right place on the page, continue to delight and inform his audiences and to elucidate his subjects. The alchemy of his ink succeeds because of the heart and mind alive within it.

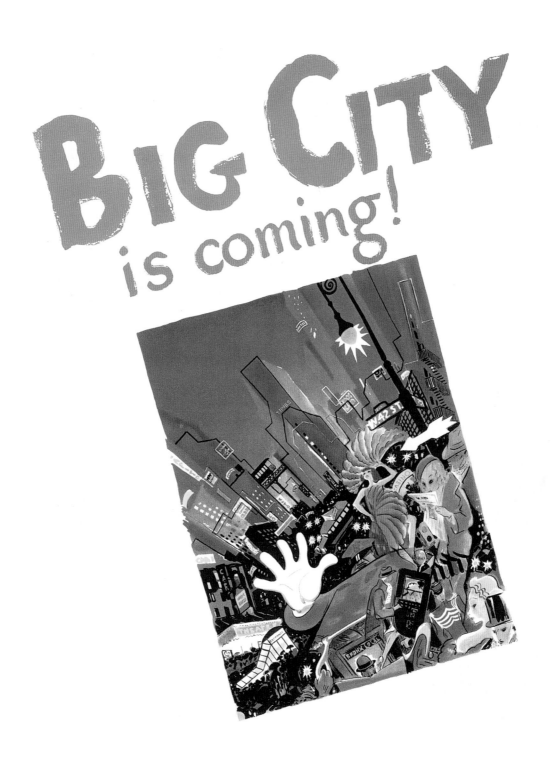

Big City is Coming! Published in MGM film publicity. 1948. Gouache

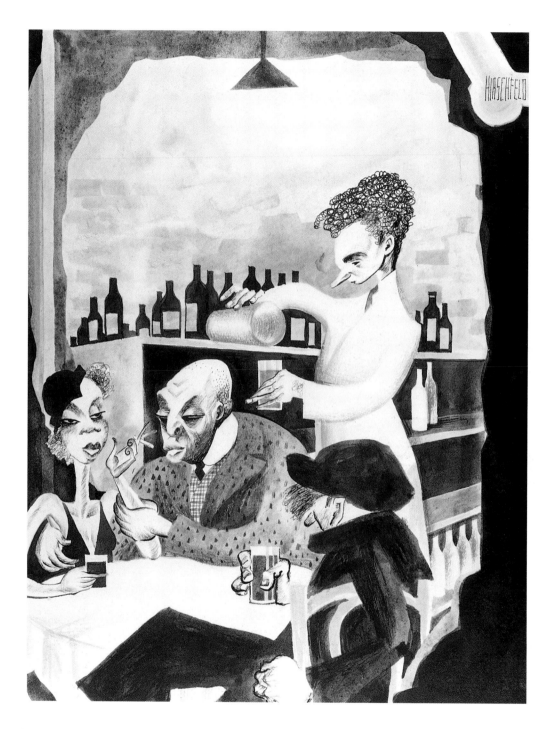

Mike's Barman Ralph. Published in *Manhattan Oases, New York's 1932 Speak-Easies (with a Gentleman's Guide to Bars and Beverages by Gordon Kahn)*. 1932. Ink and wash on board. Iconographic Collections, State Historical Society of Wisconsin. Whi(x3) 53875

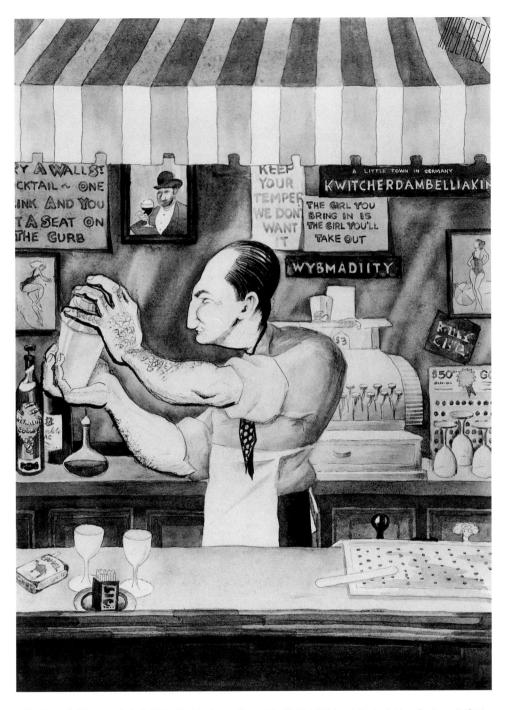

The Dizzy Club Barman Jack. Published in *Manhattan Oases, New York's 1932 Speak-Easies (with a Gentleman's Guide to Bars and Beverages by Gordon Kahn)*. 1932. Ink and wash on board. Iconographic Collections, State Historical Society of Wisconsin Whi(x3) 53872

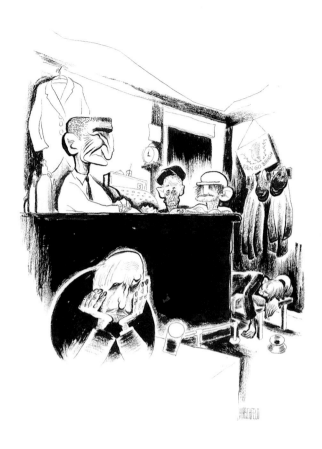

O'Leary. Published in *Manahattan Oases, New York's 1932 Speak-Easies (with a Gentleman's Guide to Bars and Beverages by Gordon Kahn)*. 1932. Ink and wash on board. Iconographic Collections, State Historical Society of Wisconsin Whi(x3) 53876

The Mansion Barman Eddie.
Published in *Manhattan Oases, New York's 1932 Speak-Easies (with a Gentleman's Guide to Bars and Beverages by Gordon Kahn)*. 1932. Ink and wash on board. Iconographic Collections, State Historical Society of Wisconsin. Whi(x3) 53874

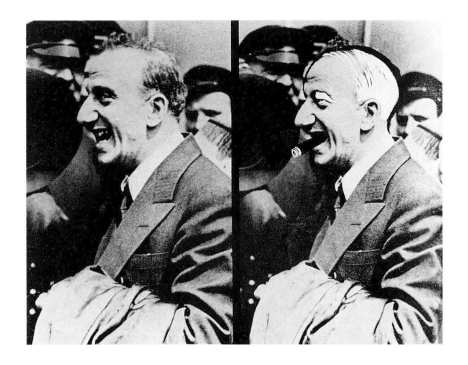

Jimmy Durante as Alfred E. Smith.
Published in *Life*. August 2, 1937.
Ink on photograph

Harold Ross as Joseph Stalin.
Published in *Life*. August 2, 1937.
Ink on photograph

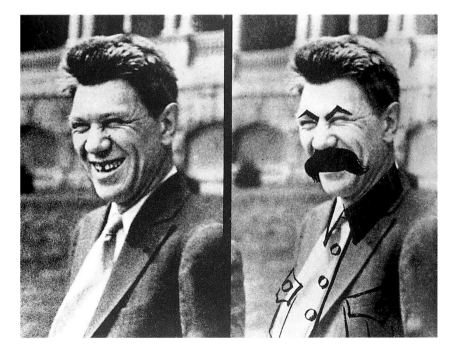

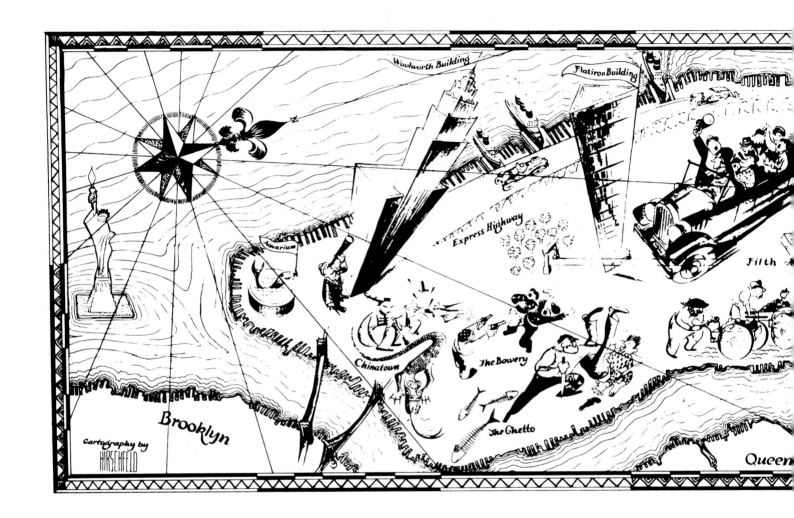

Manhattan: A Sightseer's Somewhat Distorted View. Published in the *New York Times.* November 24, 1935. Ink on board

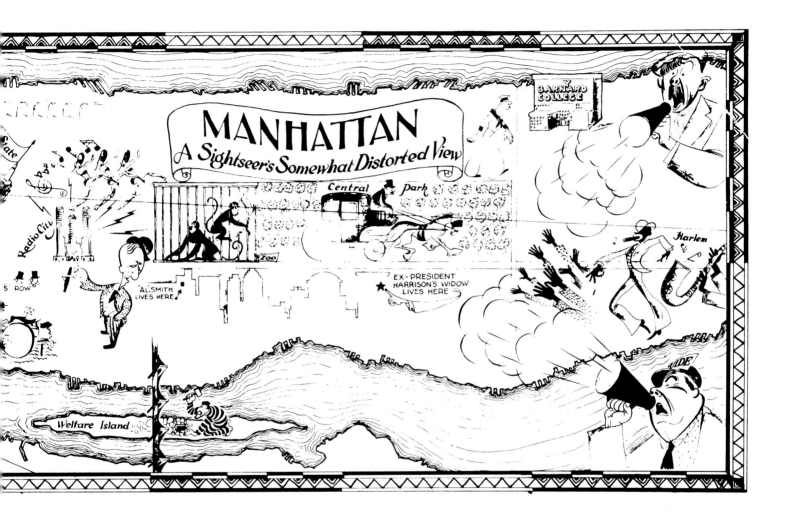

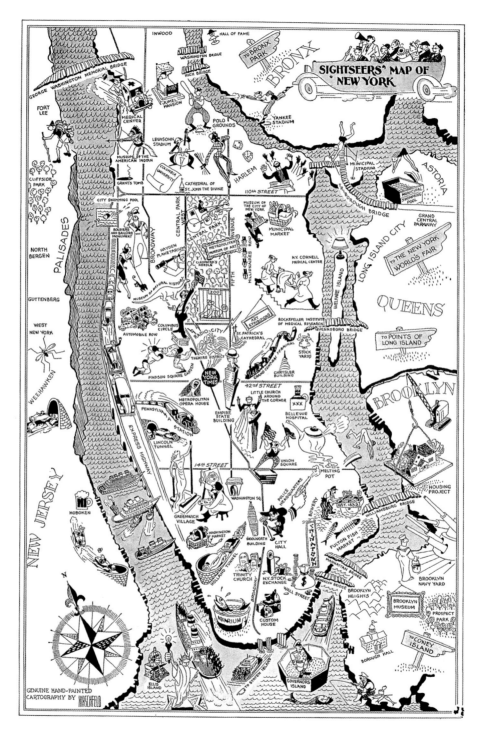

Sightseer's Map of New York
(Genuine Hand-Painted Cartography). Published in the *New York Times.* April 30, 1939.

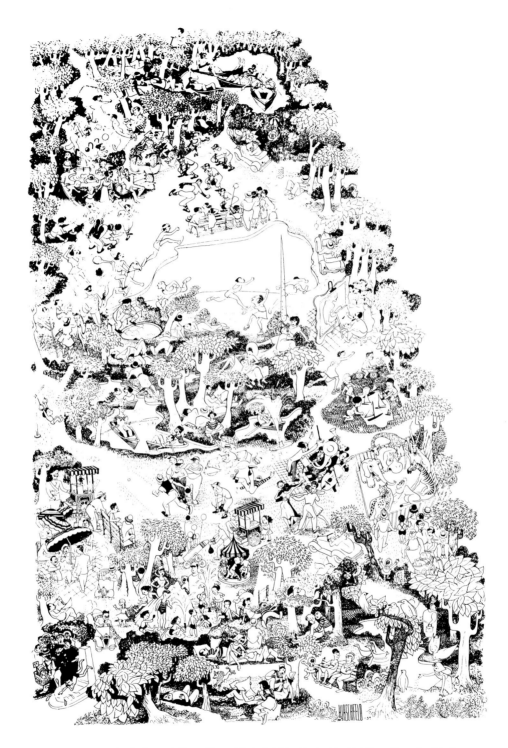

Sunday in the Park—An Eccentric Map of Central Park. Published in the *New York Times Magazine*. July 9, 1939. Ink on board. collection the Fogg Art Museum, Harvard University Art Museums, the Melvin R. Seiden Collection. 1988.437

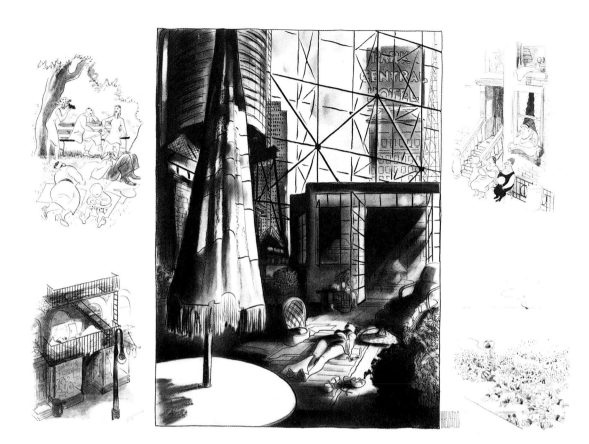

Composite of New York City Skyline
(from the artist's penthouse studio
atop The Osborne Apartments,
205 West 57th Street). Published
in the *New York Times Magazine.*
c.1942. Ink and wash on board.
Private collection

Vendor at 1939 New York World's Fair.
Published in the *New York Times
Magazine.* October 1, 1939. Ink
and gouache on board. Collection
the artist

Sugar Hill Statesman. Published in
Harlem as Seen by Hirschfeld. 1941.
Lithograph. Collection the artist

Stompin' at the Savoy. Published in
Harlem as Seen by Hirschfeld. 1941.
Lithograph. Collection the artist

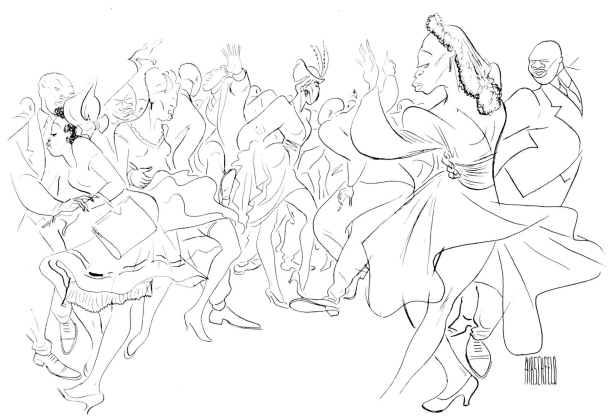

Lenox Avenue Stroll. Published in *Harlem as Seen by Hirschfeld.* 1941.
Lithograph. Collection the artist

Sharpy Family. Published in *Harlem as Seen by Hirschfeld.* 1941.
Lithograph. Collection the artist

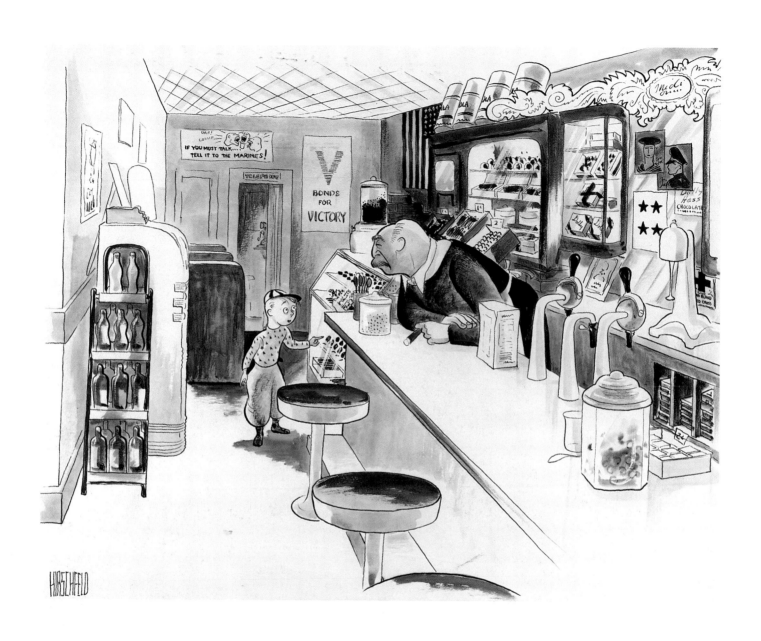

Save for the small fry, the candy store is practically deserted. From *Blitz in the Penny Candy Store*.
Published in the *New York Times Magazine*. February 28, 1943. Ink and wash on board.
Collection Cheryl and Edward S. Gordon

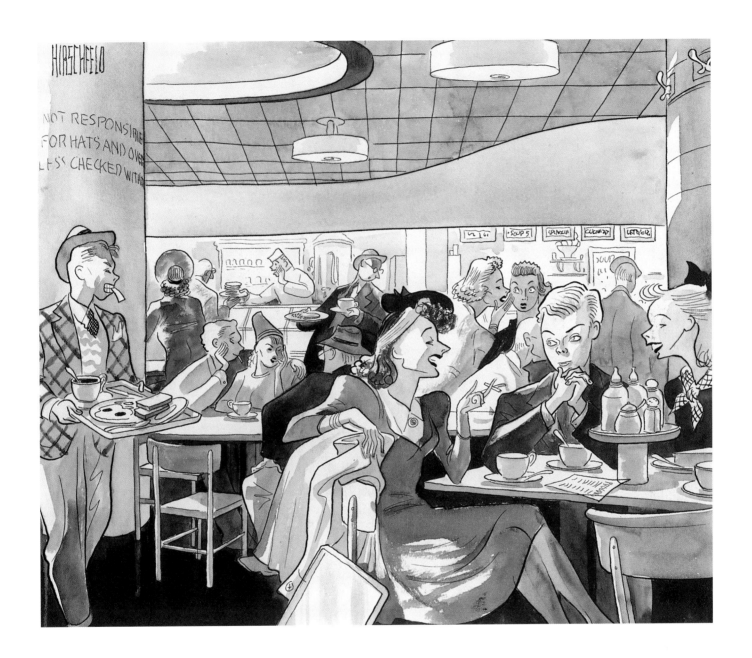

In the Village They Imitate Stage and Movie Folk in Dress and Manner.
Published in the *New York Times Magazine*. May 11, 1941. Ink and wash on board. Collection the artist

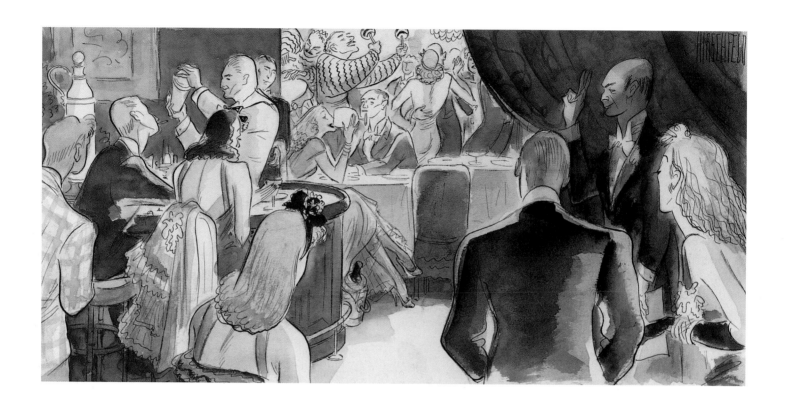

West Side Night Clubs, Everybody Is Frankly Out to Have a Good Time and Prices Are Reasonable.
Published in the *New York Times Magazine*. January 12, 1941. Ink and wash on board.
Collection Cheryl and Edward S. Gordon

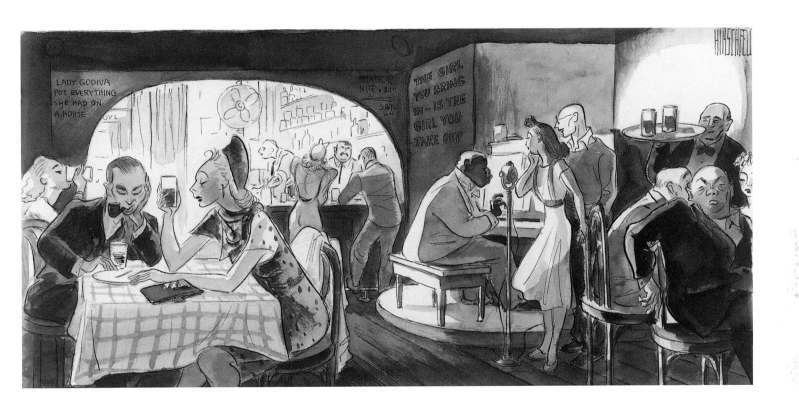

The Little Greenwich Village Clubs Are Cheap and Informal and They Foster an Honest Cheerfulness.
Published in the *New York Times Magazine*. January 12, 1941. Ink and wash on board.
Collection Cheryl and Edward S. Gordon

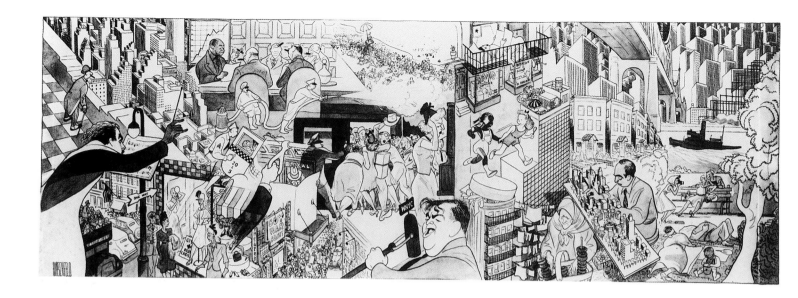

What's the Matter with New York?
(Arturo Toscanini, Fiorello La Guardia,
Robert Moses). Published in the *New
York Times Magazine*. August 1, 1943. Ink
and wash on board. Private collection

Counter-Revolution in the Village.
Published in the *New York Times
Magazine*. April 23, 1944. Ink on board

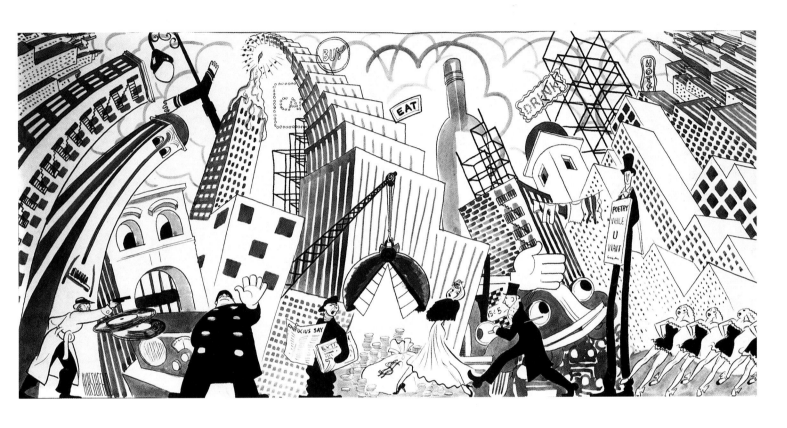

New York as Seen by William Saroyan. Published in the *New York Times Magazine*. March 31, 1940. Ink and wash on board. Collection Edwin Bacher

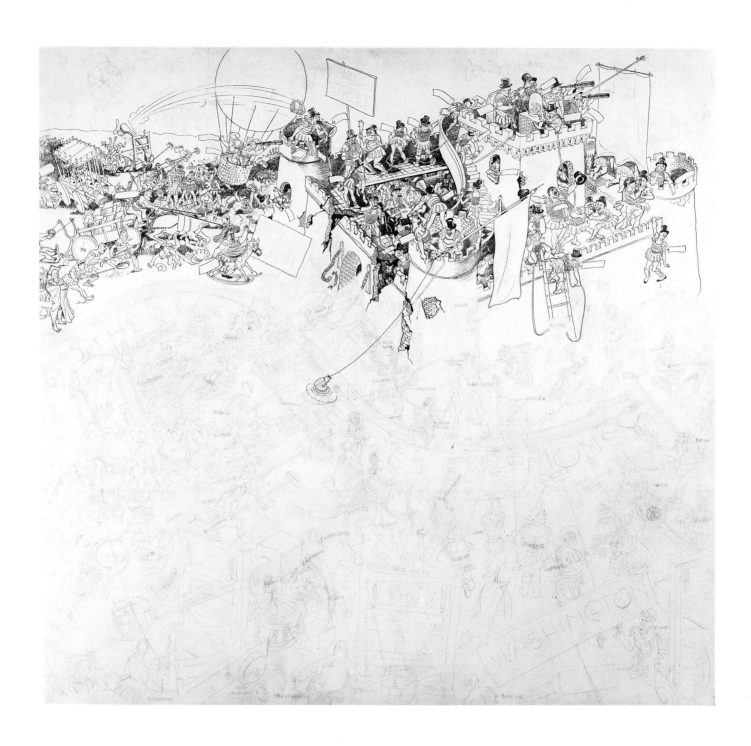

Sketch for **History of The Depression—Wall Street and Washington.** 1939.
Ink and pencil on board. Collection J. Ronald and Barbara Boer Rowes

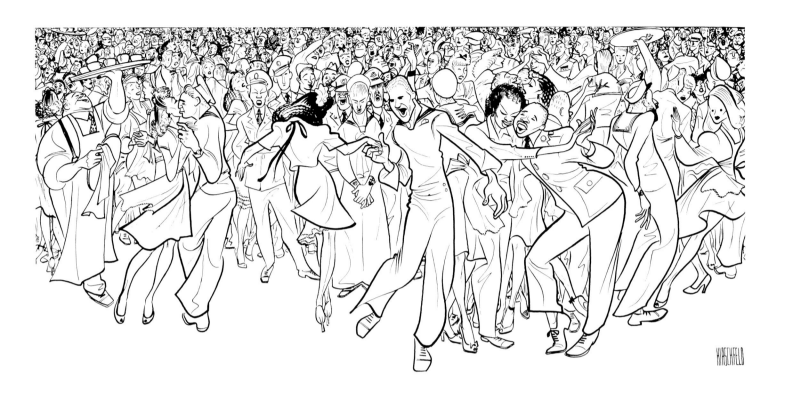

The Stage Door Canteen Reopens. Published in the *New York Times*. July 2, 1944.
Ink and pencil on board. Library of Congress Collection

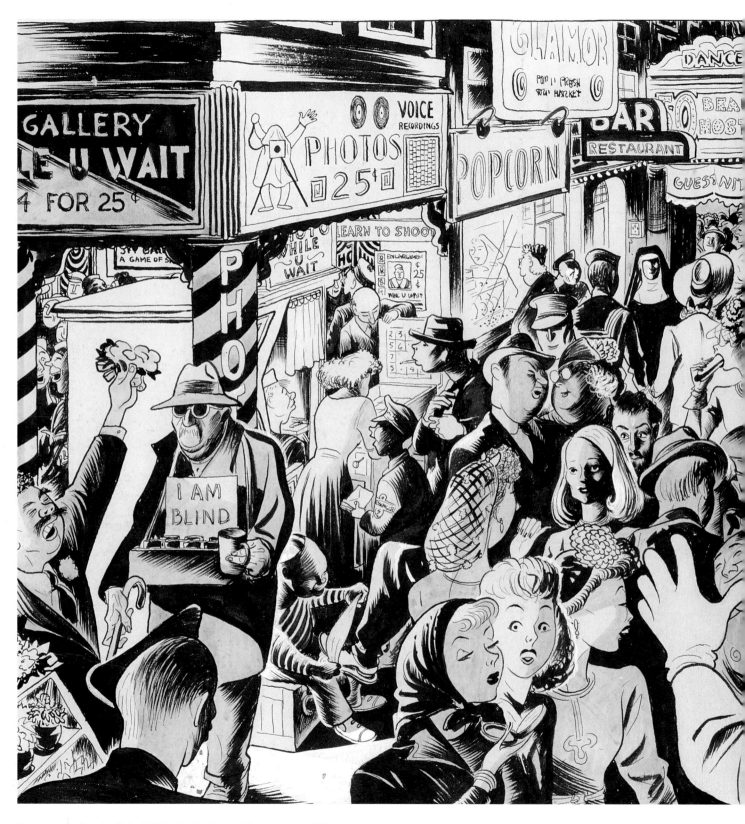

Broadway on a Saturday Night. Published in the *New York Times*. May 23, 1943. Ink on board. Collection Joseph M. Erdelac

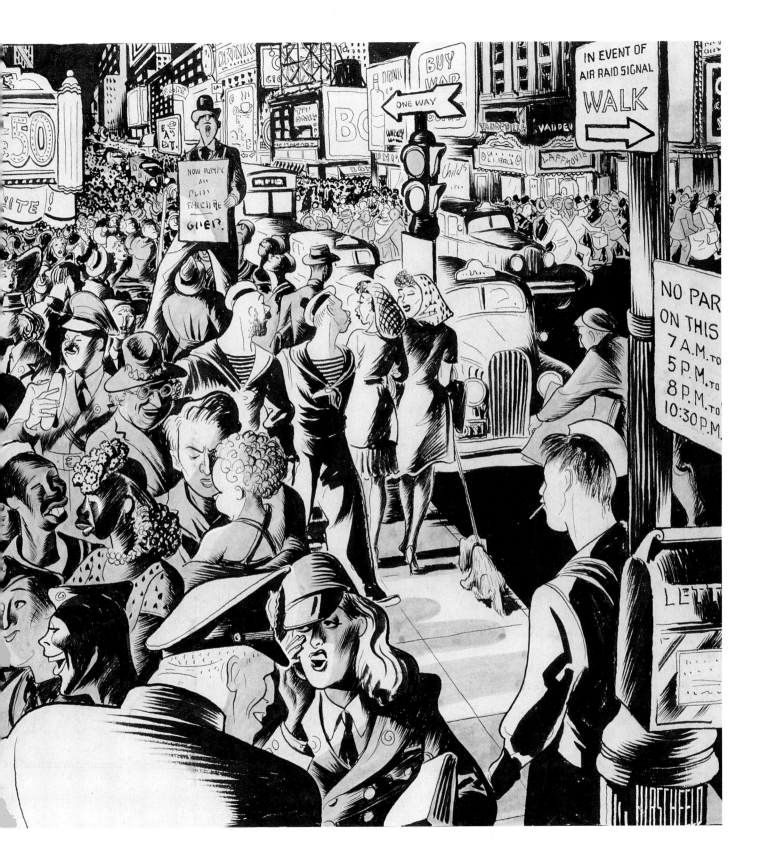

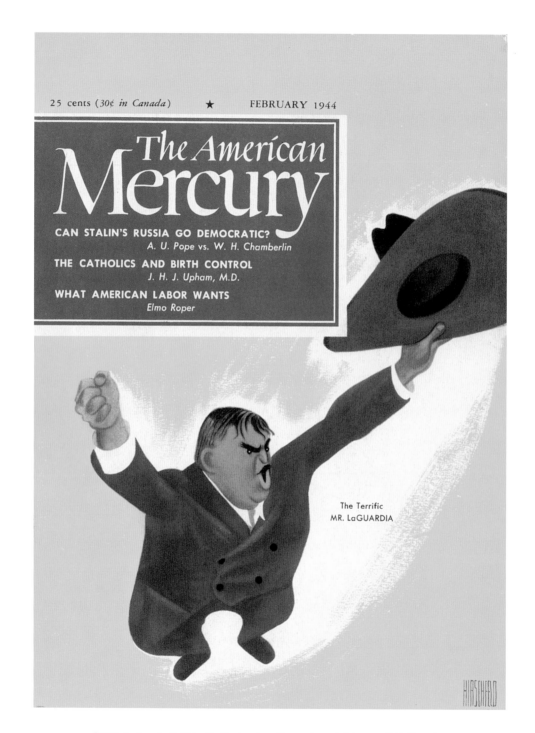

Fiorello La Guardia. Published in *The American Mercury* (cover). February 1944. Gouache

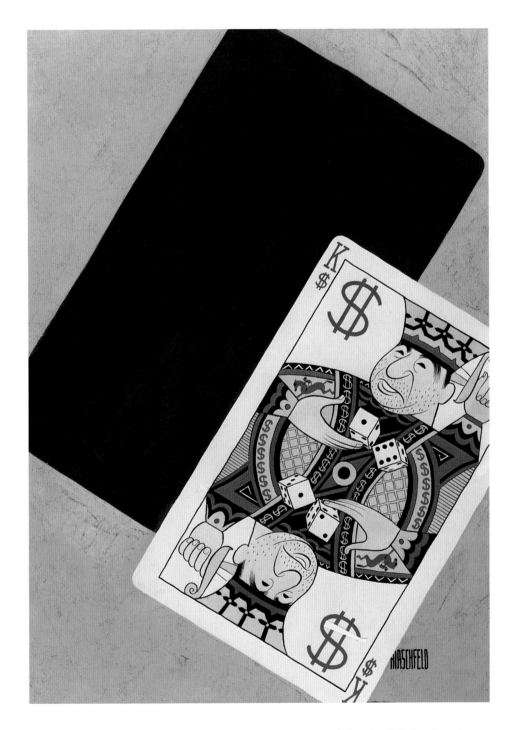

Frank Costello. Published in *The American Mercury* (cover). August 1950. Gouache. Collection the artist

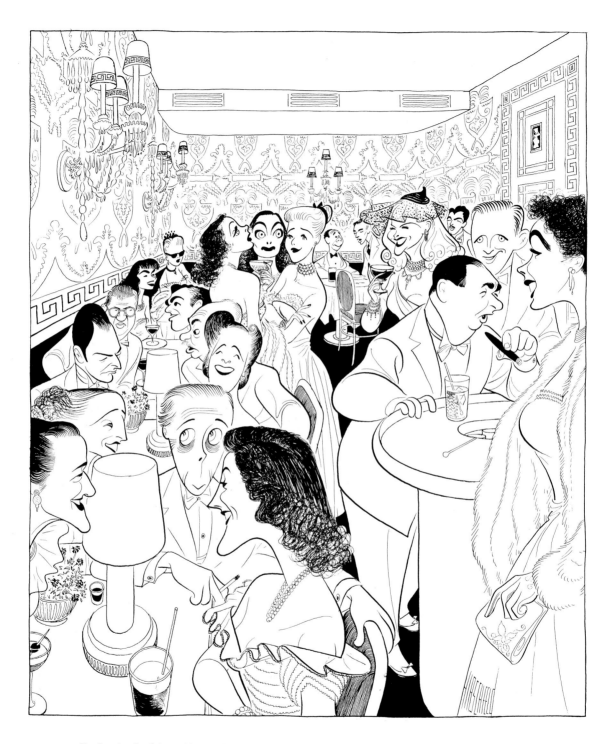

The Crowd at Gogi's Larue (Margaret Truman, Winthrop Rockefeller, David O. Selznick, Lana Turner, Sarah Churchill, Sophie Gimbel, Conrad Hilton, Tony Martin, Hedy Lamarr, Joan Crawford, Ginger Rogers, Bert Lahr, Robert Taylor, Hope Hampton, Bing Crosby, Leon Henderson, Elizabeth Taylor, Duke of Windsor, Duchess of Windsor). Published in *Collier's*. February 2, 1952. Ink on board. Private collection

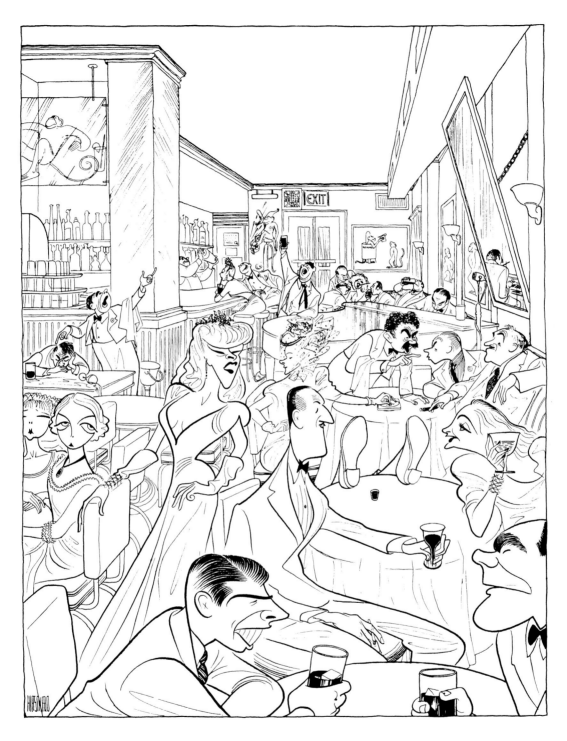

The Monkey Bar at The Hotel Elysée (Lillian Gish, Dorothy Gish, Gertrude Niesen, Helen Hayes, Charles MacArthur, Ben Hecht, Louis Calhern, Tallulah Bankhead, Joe DiMaggio, Paul Douglas). Published in *Collier's*. November 25, 1950. Ink on board. Private collection

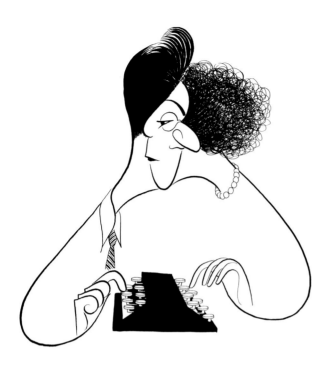

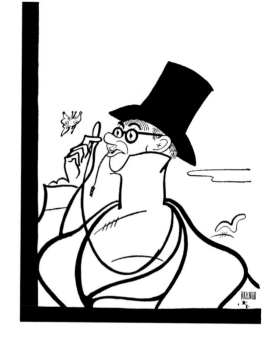

George S. Kaufman and Edna Ferber.
Published in *The Vicious Circle* by
Margaret Case Harriman. 1951.
Ink on board. Collection Douglas
Colby

Harold Ross. Published in *The Vicious
Circle* by Margaret Case Harriman.
1951. Ink on board. Collection J.
Ronald and Barbara Boer Rowes

Robert Benchley. Published in *The
Vicious Circle* by Margaret Case
Harriman. 1951. Ink on board.
Collection the artist

Dorothy Parker. Published in
The Vicious Circle by Margaret Case
Harriman. 1951. Ink on board.
Private collection

Frank Case on Hotel Algonquin
menu. Published in *The Vicious Circle*
by Margaret Case Harriman. 1951.
Ink on menu. Collection J. Ronald and
Barbara Boer Rowes

A Greenwich Village Childhood.
Published in *Manhattan and Me* by Oriana Atkinson. 1954. Ink on board

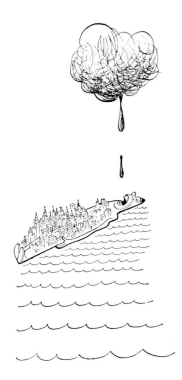

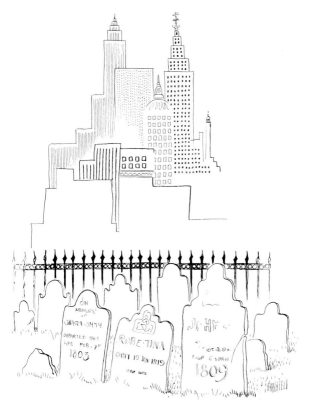

House of the Lions. Published in *Manhattan and Me* by Oriana Atkinson. 1954. Ink on board. Collection of the artist

Wide Waste of Waters. Published in *Manhattan and Me* by Oriana Atkinson. 1954. Ink on board. Collection the artist

Tip of the Town. Published in *Manhattan and Me* by Oriana Atkinson. 1954. Ink on board. Collection the artist

The Algonquin Round Table (Robert Sherwood, Dorothy Parker, Robert Benchley, Alexander Woollcott, Heywood Broun, Marc Connelly, Franklin P. Adams, George S. Kaufman, Frank Crowninshield, Alfred Lunt, Lynn Fontanne, Edna Ferber, and host Frank Case). Published in *Horizon Magazine*. July 1962. Ink on board. Private collection

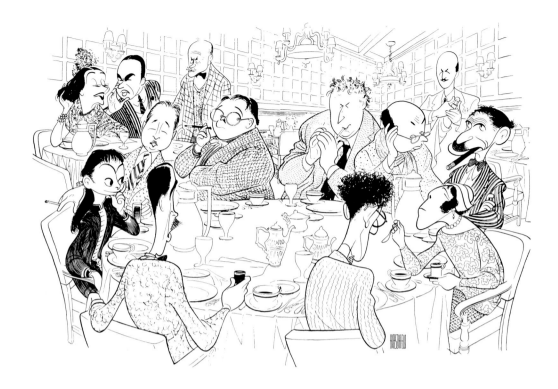

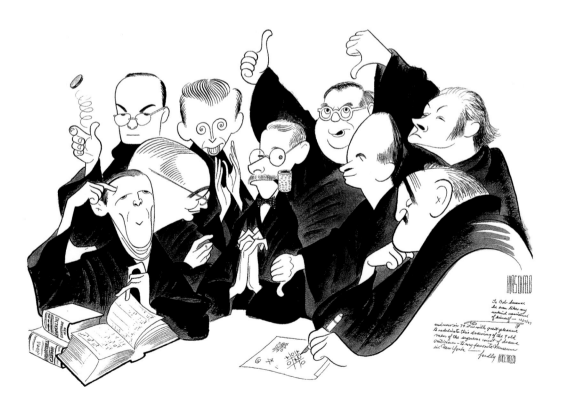

Theatre Critics (Howard Barnes, the *Tribune*; Richard Watts Jr., the *New York Post*; Brooks Atkinson, the New York Times; Louis Kronenberger, *PM*; Robert Garland, *Journal-American*; John Chapman, the *Daily News*; Ward Morehouse, the *Sun*; William Hawkins, Jr., *World Telegram*; Robert Coleman, the *Daily Mirror*). Published in the *New York Times Magazine*. c. 1948. Ink and wash on board. Museum of the City of New York. Gift of Robert Garland, 56.59.22

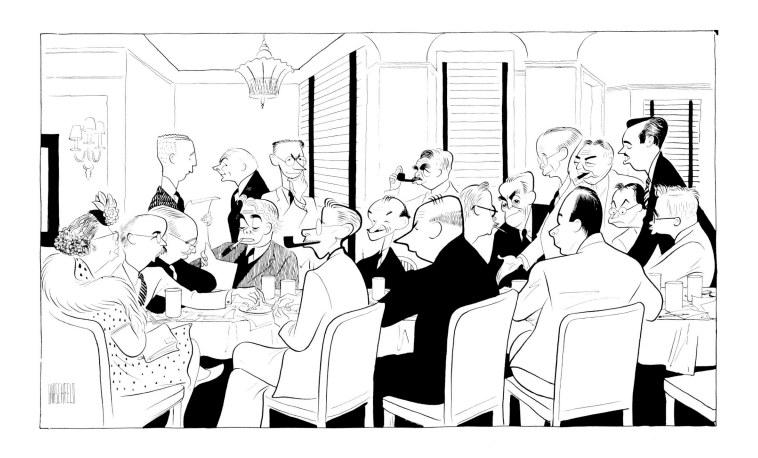

The New York Drama Critics Circle
(Rosamund Gilder, Joseph Wood Krutch, Richard Watts Jr., John Mason Brown, Walter Winchell, George Jean Nathan, Sidney Whipple, Brooks Atkinson, Arthur Pollock, Grenville Vernon, Stark Young, Wolcott Gibbs, Burns Mantle, Richard Lockridge, Louis Kronenberger, Kelcey Allen, Oliver Claxton, John Anderson, John Gassner.) Published in the *New York Times.* April 27, 1941. Ink and wash on board. Collection J. Ronald and Barbara Boer Rowes

Broadway First Nighters. (Wolcott Gibbs, *New Yorker;* John Mason Brown, *S.R.L.;* Richard Watts, *Post;* Leo Lerman, *Madamoiselle;* Abel Green, *Variety;* Dorothy Kilgallen, *Journal-American;* John McClain, *Journal-American;* Mark Barron, *Associated Press;* John Chapman, *Daily News;* Hobe Morrison, *Variety;* Ward Morehouse, *Theatre Arts;* Whitney Bolton, *Morning Telgraph;* Mr. and Mrs. Louis Kronenberger, *Time Magazine;* Tom Prideaux, *Life Magazine;* Tom Wenning, *Newsweek;* Mr. and Mrs. Brooks Atkinson, *Times;* Mr. and Mrs. Walter Kerr, *Herald-Tribune;* Rowland Fields, *Newark News;* Walter Winchell, *Mirror;* Ed Sullivan, *Daily News;* Earl Wilson, *Post;* Robert Sylvester, *News;* Louis Sobol, *Journal-American;* Mr. and Mrs. Leonard Lyons, *Post;* George S. Kaufman; Truman Capote; Mr. and Mrs. Moss Hart (Kitty Carlisle); Mr. and Mrs. Martin Gable (Arlene Francis); Mr. and Mrs. Sidney Lumet (Gloria Vanderbilt); Howard Cullman; Robert Dowling; Roger Stevens; Robert Whitehead; Mr. and Mrs. William Zeckendorf; Melanie Kahane,

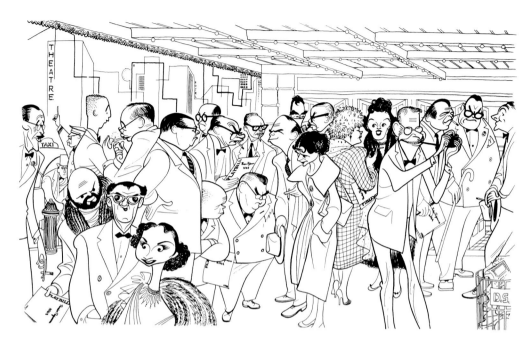

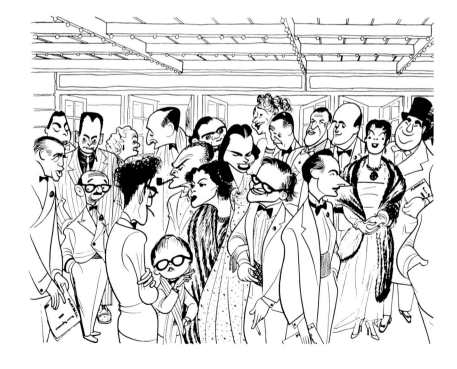

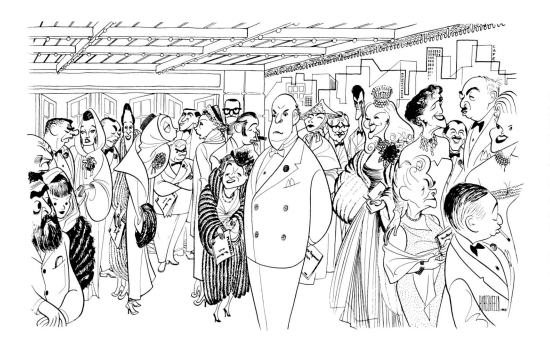

Playbill Room designer; Abe Feder, Playbill Room lighting designer; Lester Markel, *Times*; Mr. and Mrs. Gilbert Miller; Mr. and Mrs. Clifton Daniels (Margaret Truman); Mr. and Mrs. Carl VanVechten (Fania Marinoff); Vinton Freedly; Radie Harris, *Variety*; Harold Arlen; Louise Beck; Marlene Dietrich; Allene Talmey, *Vogue*; Herbert Bayard Swope; Cole Porter; Noel Coward; Frank Farrell, *World-Telegram Sun*; Sol Hurok, Elsa Maxwell; Mr. and Mrs. Al Hirschfeld, *Times* (Dolly Haas); Alexander Ince, *Theatre Arts*; Mr. and Mrs. Oscar Hammerstein; Mr. and Mrs. Richard Rodgers; Lillian Gish; Louis Lotito; Mainbocher; Dave Garroway; Robert Coleman, *Mirror*; Mr. and Mrs. Ira Katzenberg; Valentina; Frank Aston, *World-Telegraph Sun*; Henry Hewes, *S.R.L.*; Hope Hampton; Mr. and Mrs. Lawrence Langner (Armina Marshall); Danton Walker, *News*; Theresa Helburn; Mr. and Mrs. Billy Rose (Joyce Mathews); Ink on board. For The Playbill Room of Hotel Manhattan. c.1958. New York Public Library, Billy Rose Theater Collection

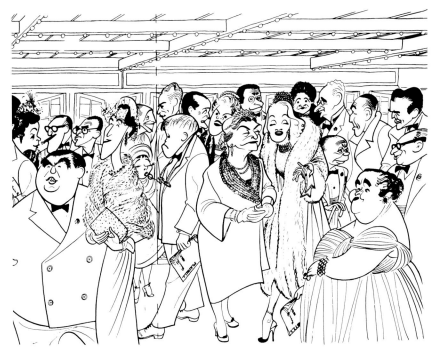

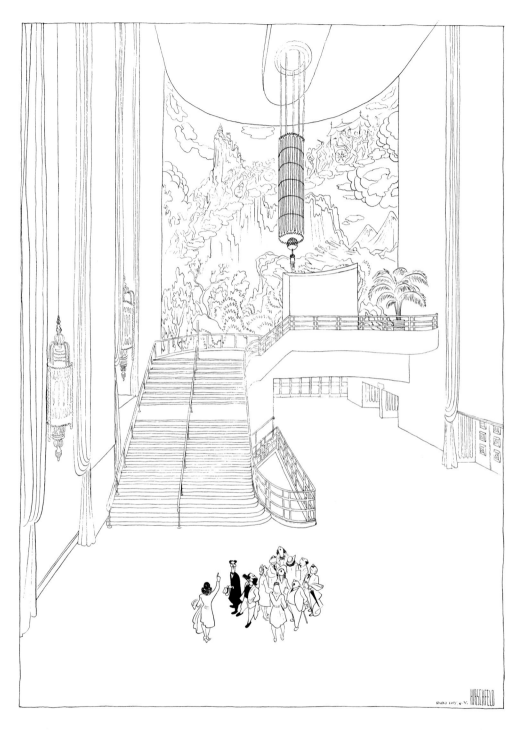

Long Time No Sight-See (S. J. Perelman and Hirschfeld standing in front of a group touring Radio City Music Hall). Published in "Gotham Ha!" by S. J. Perelman, *Holiday*. April 1949. Ink on board. Collection Cheryl and Edward S. Gordon

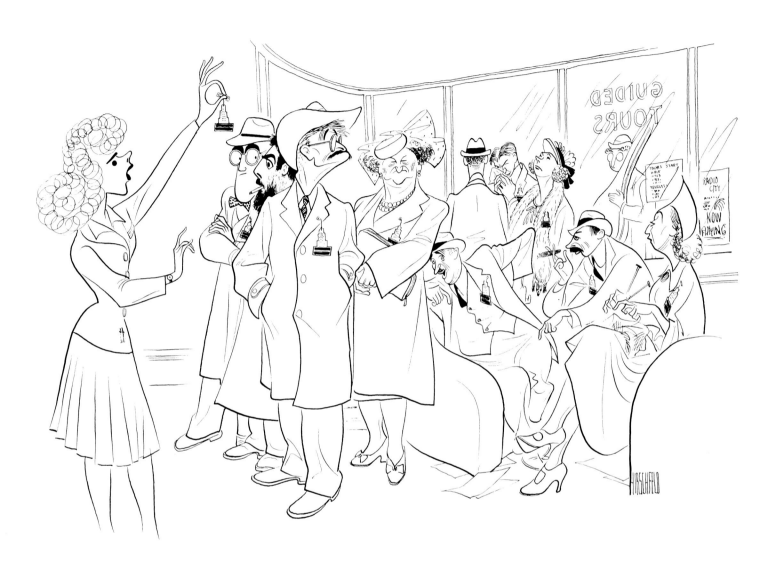

"Attention Green Tags, I'm Miss Savacool, your guide." (Empire State Building Tour) Published in "Gotham Ha!"
by S. J. Perelman, *Holiday*. April 1949. Ink on board. Private collection

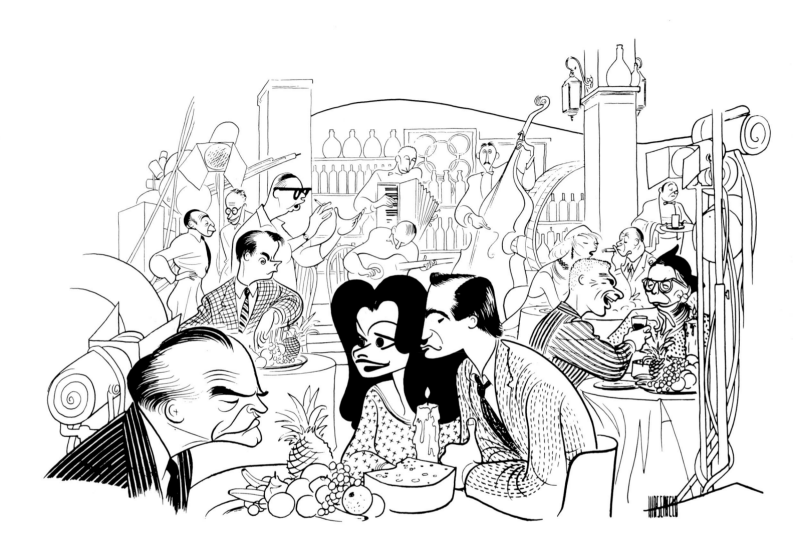

On Location Filming Young Doctors at Leone's Restaurant, New York City
(Ben Gazzara, Ina Balin, Frederic March, Dick Clark, Eddie Albert, Aline MacMahon, Phil Karlson).
United Artists Film Publicity. 1961. Ink on board. Collection the artist

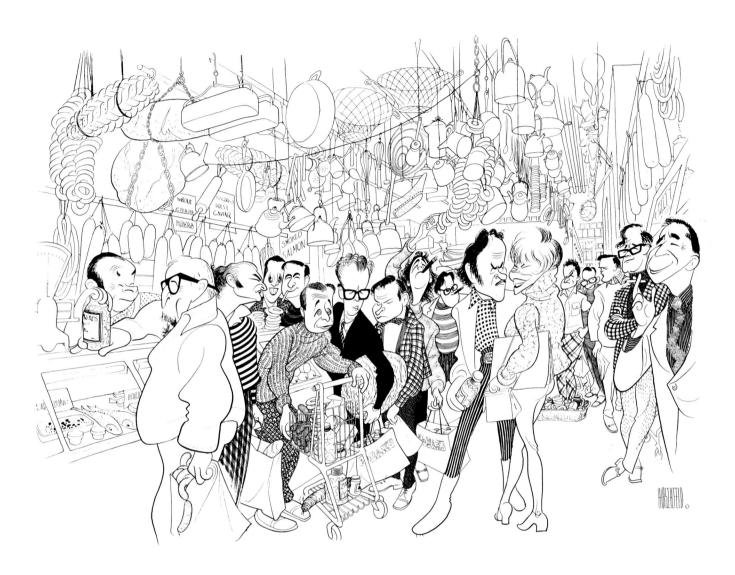

The Upper West Side Intelligentsia Meet at Zabar's (Anne Jackson, Eli Wallach, Joseph Heller, Dwight Macdonald, Theodore Solotaroff, Norman Podhoretz, Irving Kristal, Murray Kempton, James Wechsler, Jack Gelber, Jason Epstein, Meyer Levin, Irving Howe, Robert Silvers, Wilfred Sheed, Alfred Kazin, and Sam behind the counter selling pickles). Published in the *New York Times*. May 9, 1971. Ink and pencil on board. Private collection

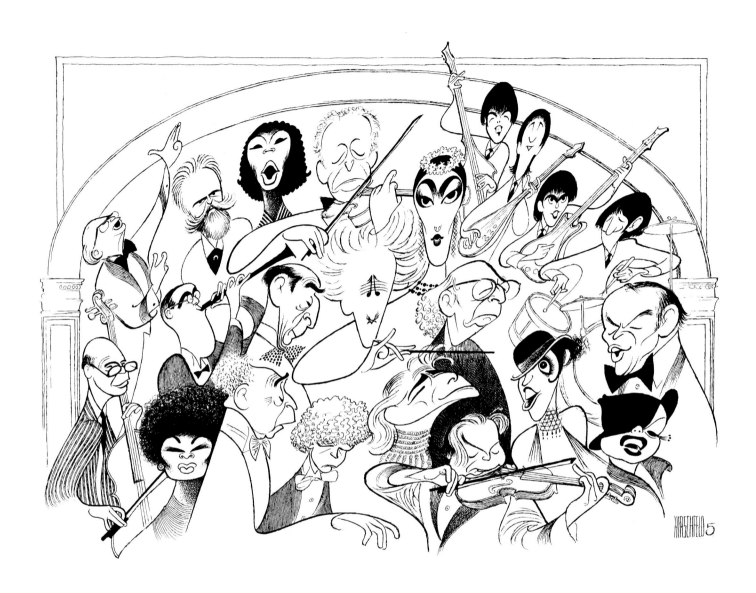

Carnegie Hall Notables (Pablo Casals, Piotr Tchaikovsky, Marion Anderson, Jascha Heifetz, Mstislav Rostropovich, Arthur Rubenstein, Vladimir Horowitz, Arturo Toscanini, Benny Goodman, Leonard Bernstein, Issac Stern, Maria Callas, Leontyne Price, The Beatles, Frank Sinatra, Judy Garland, Liza Minnelli, Aaron Copland). Published in special advertising section to mark the 100th anniversary of Carnegie Hall. Published in *Business Week*. 1991. Ink on board

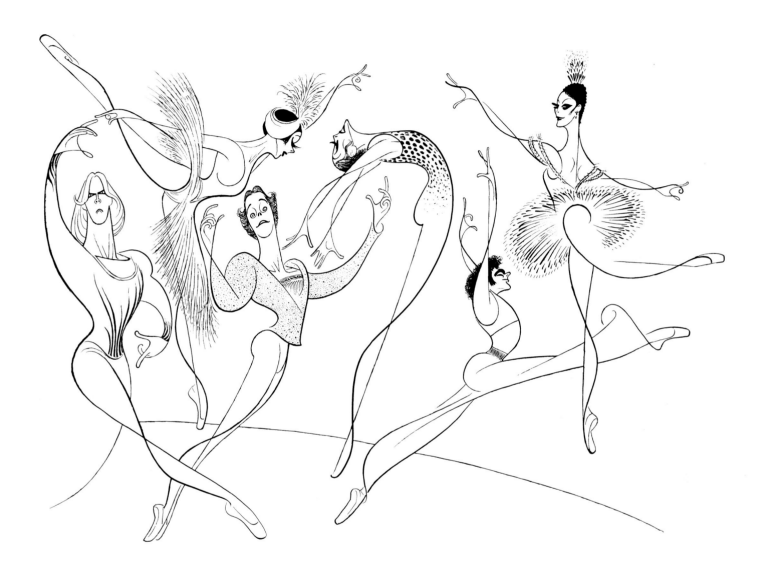

American Ballet Theatre (Alexander Godunov, Martine Von Hamel, Anthony Dowell, Natalia Makarova, Fernando Bujones, Cynthia Gregory). Published in the *New York Times*. May 4, 1980. Ink on board

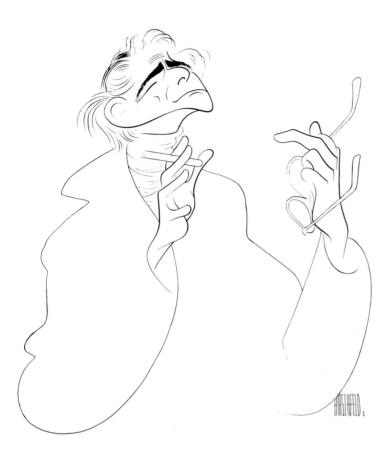

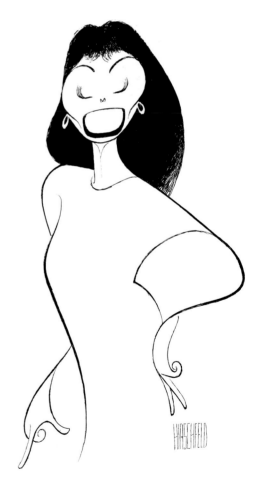

Leonard Bernstein. Published in
the *New York Times*. July 9, 1972.
Etching. Collection the artist

Lena Horne. BMG album cover.
1999. Ink on board.

Louis Armstrong. BMG album cover. 1999. Ink on board.

George Gershwin. BMG album cover.
1991. Ink on board.

Benny Goodman. BMG album cover.
1996. Ink on board.

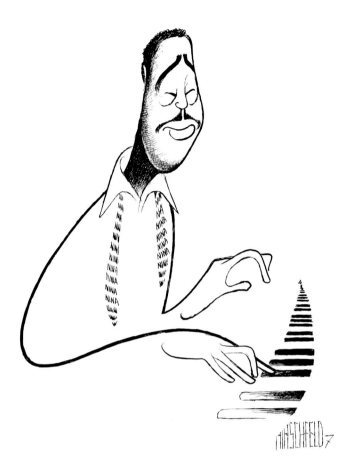

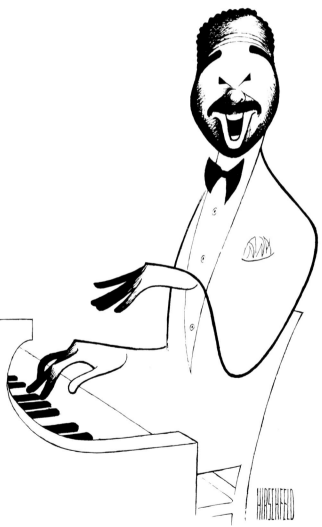

Duke Ellington. BMG album cover. 1996. Ink on board.

Bobby Short. Published in the *New York Times*. December 7, 1986. Ink on board.

S. J. Perelman. Published in the *New York Times Book Review.* August 30, 1970.
Ink on board. Collection the artist

Richard Maney: Lucubrations of a Press Agent. Published in the *New York Times Magazine*. c.1946.
Ink and wash on board. Collection The Margo Feiden Galleries Ltd., New York

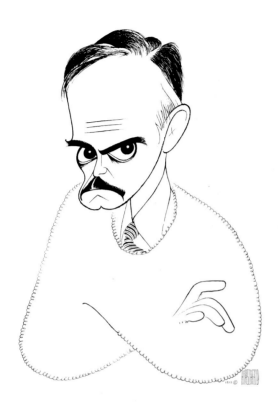

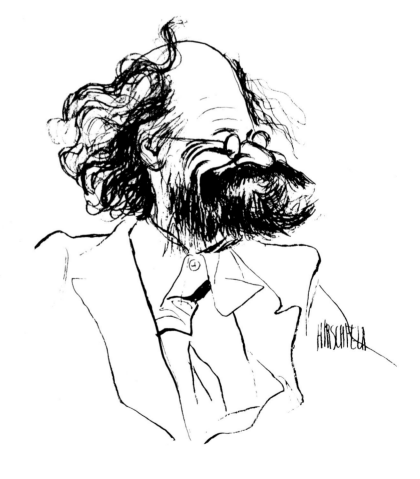

Eugene O'Neill. Logo for Eugene
O'Neill Theatre Center program.
1988. Ink on board. Collection
Eugene O'Neill Theater Center

Joe Gould. c.1942. Lithograph.
Collection the artist

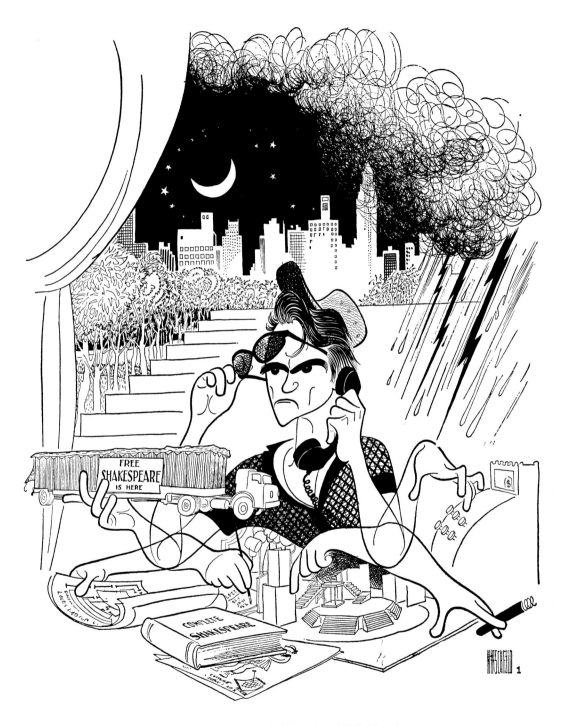

Joe Papp. Published in the *New York Times*. June 6, 1965. Ink on board.
Collection Helen Epstein

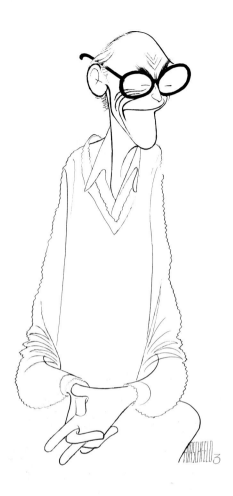

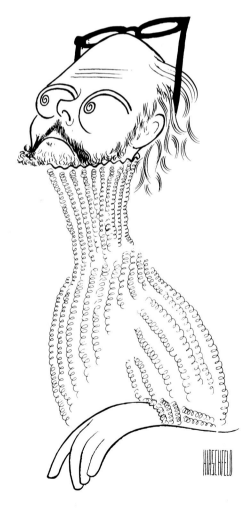

Arthur Miller at Eighty. Published in the *New York Times*. October 29, 1995. Ink on board. Collection J. Ronald and Barbara Boer Rowes

Hal Prince. Published in the *New York Times*. February 24, 1978. Ink on board. Private collection

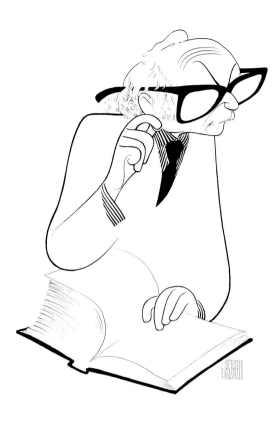

Lee Strasberg. Published in the
New York Times. November 26, 1976.
Ink on board. Private collection

Margaret Colin in *Jackie: An American
Life.* Published in the *New York Times.*
November 9, 1997. Ink on board.
Private collection

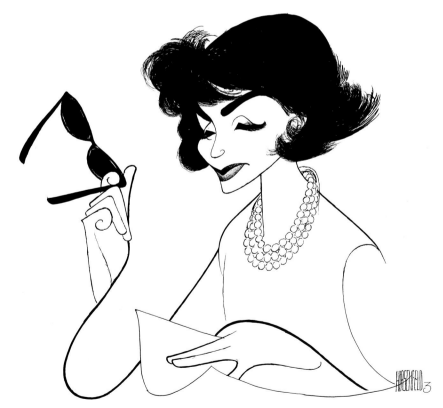

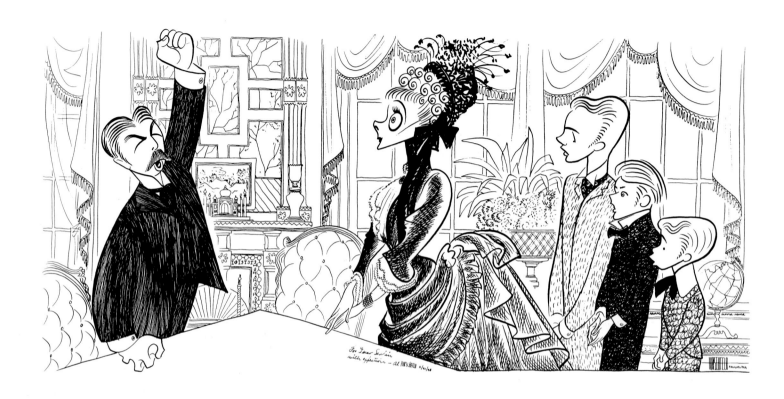

Life With Mother (Howard Lindsay,
Dorothy Stickney, Robert Antoine,
David Frank, Robert Wade). Published
in the *New York Times*. October 17,
1948. Ink and wash on board. Museum
of the City of New York. Gift of Mrs.
Oscar Serlin, 77.72.25

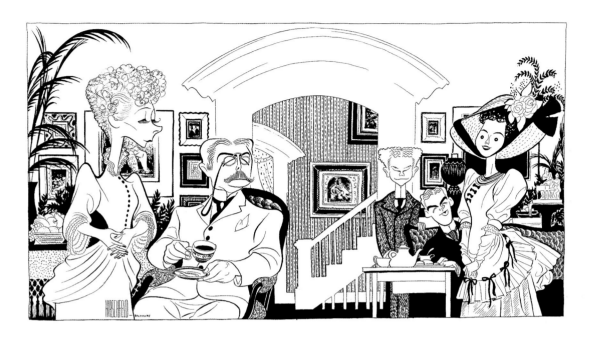

Life With Father (Dorothy Stickney, Howard Lindsay, Richard Simon, John Drew Devereaux, Teresa Wright). Published in the *New York Times*. November 5, 1939. Ink on board. Museum of the City of New York. Gift of Mrs. Oscar Serlin, 77.72.17

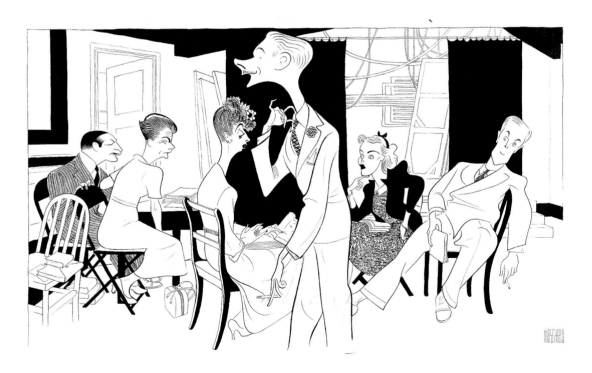

The First Reading of *The Man Who Came to Dinner* (John Wildberg, Cheryl Crawford, Paula Laurence, Clifton Webb, Claudia Morgan, John Hoysradt). Published in the *New York Times*. August 3, 1941. Ink and wash on board. Museum of the City of New York. Gift of the American Theatre Wing, 52.41.16

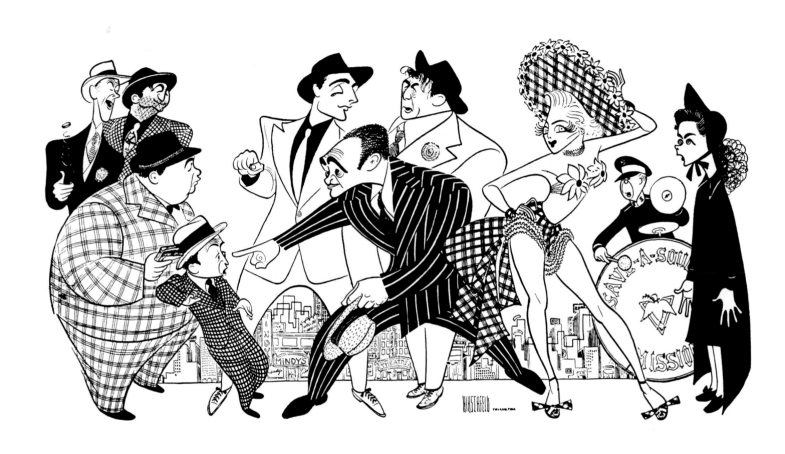

Guys & Dolls (Douglas Deane, Tom Pedi, Stubby Kaye, Johnny Silver, Robert Alda, Sam Levene,
B. S. Pully, Vivian Blaine, Pat Rooney, Sr., Isabel Bigley). Published in the *New York Times*. November 11, 1950.
Ink on board. Collection Jo Sullivan

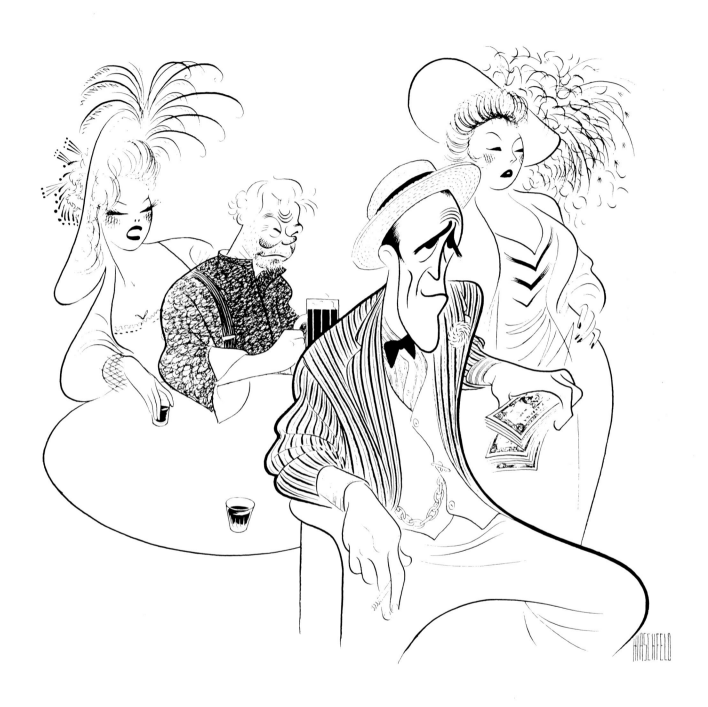

The Iceman Cometh (television production with Jason Robards, Myron McCormick).
CBS Advertisement. 1960. Ink on board. Private collection

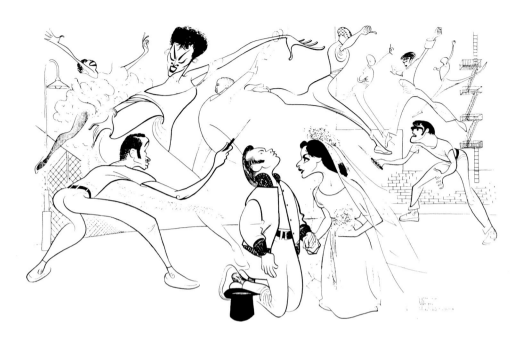

West Side Story (Ken Leroy, Mickey Calin, Chita Rivera, Larry Kert, Carol Lawrence). Published in the *New York Times*. September 22, 1957. Ink on board. The Theater Arts Collection, Harry Ranson Humanities Research Center, the University of Texas at Austin

West Side Story (George Chakiris and Rita Moreno, Richard Beymer and Natalie Wood). United Artists Film Publicity, 1961. Ink on board. Private collection

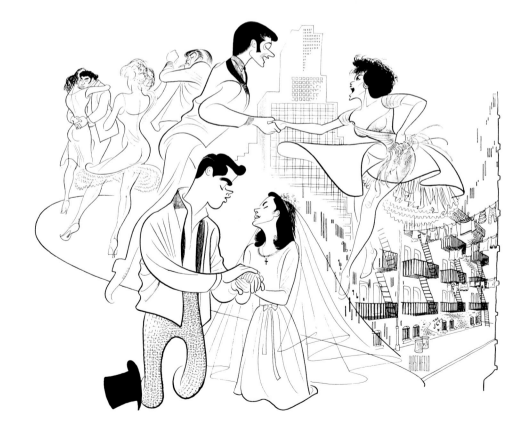

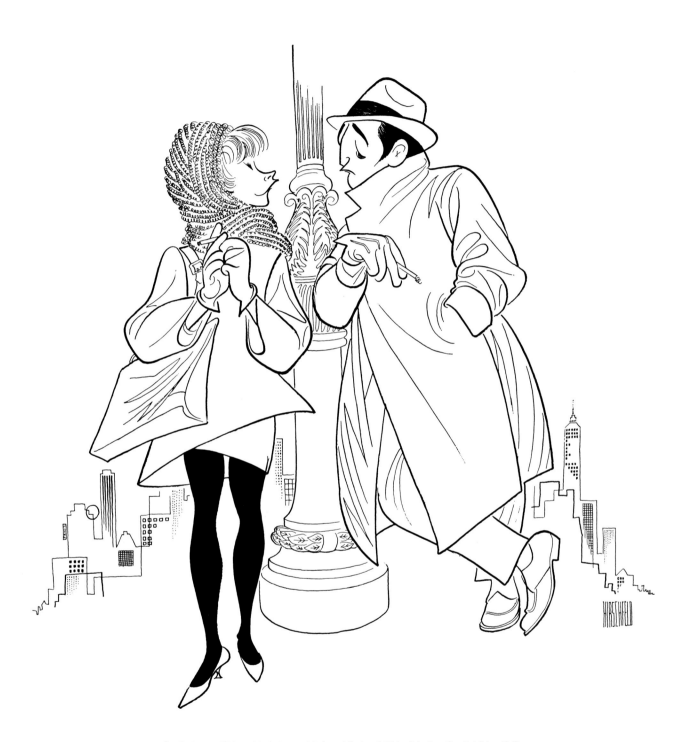

Two for the Seesaw (Shirley MacLaine and Robert Mitchum). United Artists Film Publicity. 1962.
Ink on board. Collection the artist

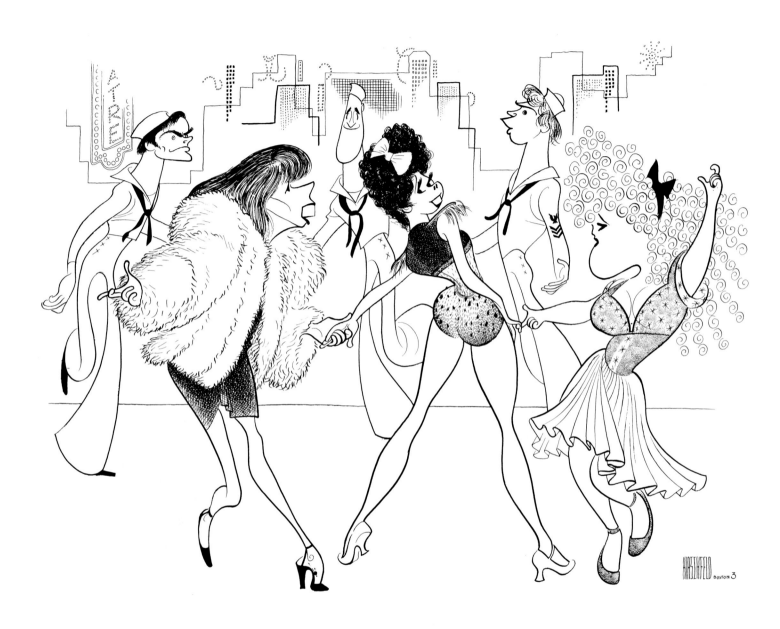

On the Town (Bernadette Peters, Phyllis Newman, Donna McKechnie, Jess Richards,
Remak Ramsey, Ron Husman). Published in the *New York Times*. October 31, 1971.
Ink on board. Private collection

The Prisoner of Second Avenue
(Jack Lemmon and Anne Bancroft).
Warner Brothers Film Publicity.
1975. Ink on board. Private
collection

The Apartment (Jack Lemmon and
Shirley MacLaine). United Artists
Film Publicity. 1960. Ink on board.
Davenport Museum of Art, Iowa.
Gift of Mr. and Mrs. G. Laverne
Flambo in memory of Milt Troehler,
67.1142

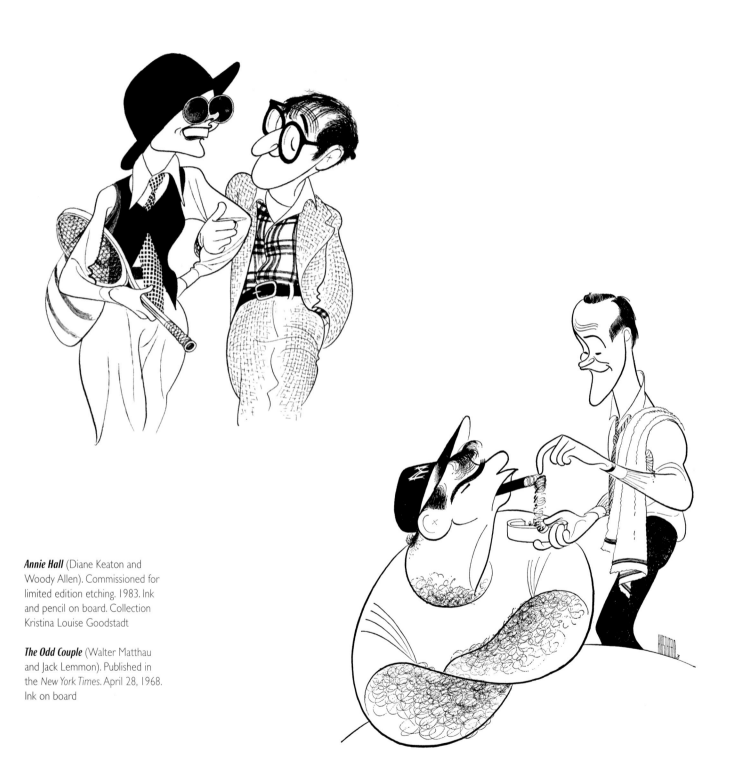

Annie Hall (Diane Keaton and Woody Allen). Commissioned for limited edition etching. 1983. Ink and pencil on board. Collection Kristina Louise Goodstadt

The Odd Couple (Walter Matthau and Jack Lemmon). Published in the *New York Times*. April 28, 1968. Ink on board

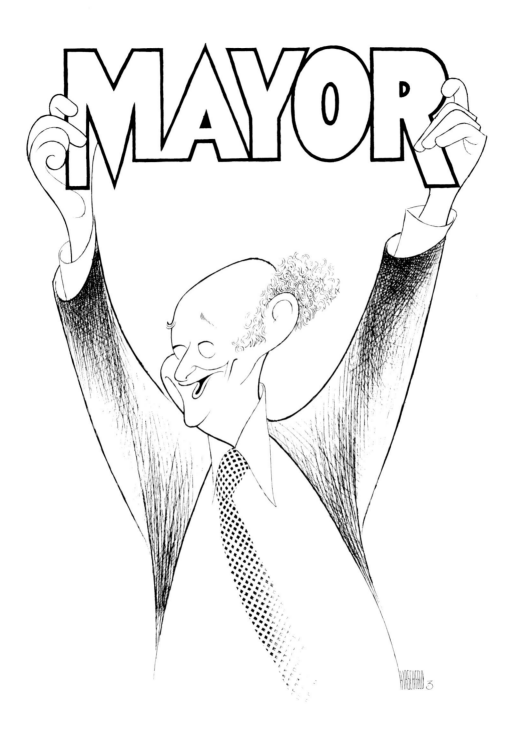

Ed Koch. Logo for Off-Broadway musical, Mayor. 1985.
Ink on board. Private collection

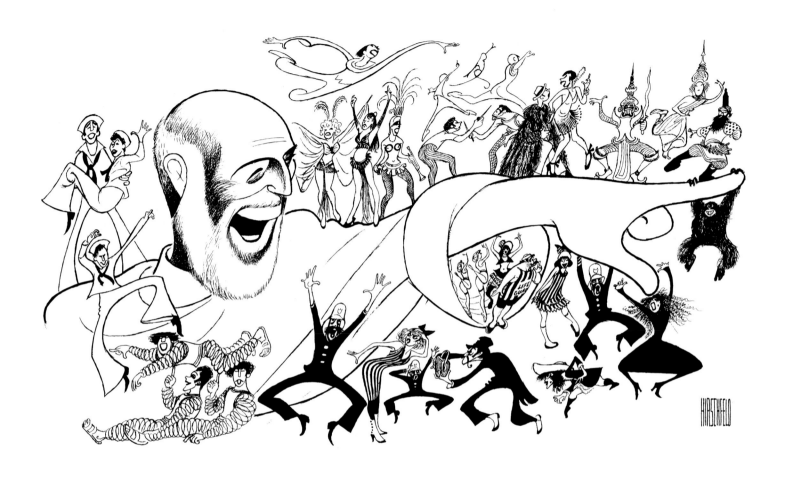

Jerome Robbins' Broadway. Published in the *New York Times.* February 19, 1989.
Ink on board. Collection the Margo Feiden Galleries Ltd., New York

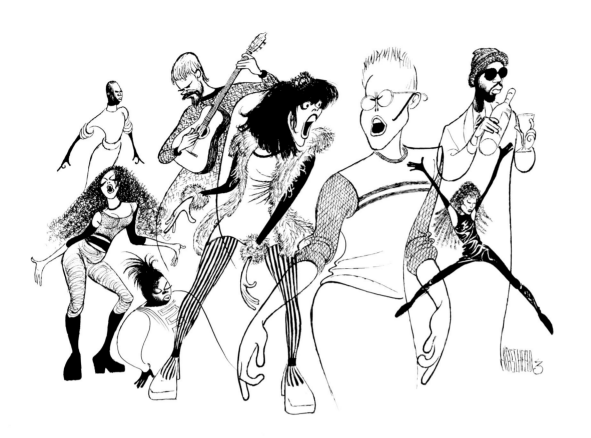

Rent (Fredi Walker, Daphne Rubin-Vega, Taye Diggs, Adam Pascal, Wilson Jermaine Heredia, Anthony Rapp, Jesse L. Martin, Idina Menzel). Published in the *New York Times*. April 28, 1996. Ink on board. Private collection

Largely New York (Bill Irwin, Jeff Gordon, Steve Clemente, Leon Chesney, Margaret Eginton). Published in the *New York Times*. May 14, 1989. Ink on board. Harvard Theatre Collection, Houghton Library, gift of Melvin R. Seiden

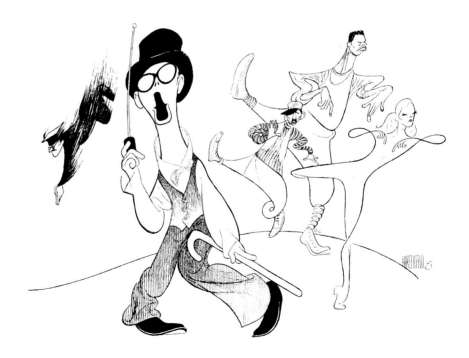

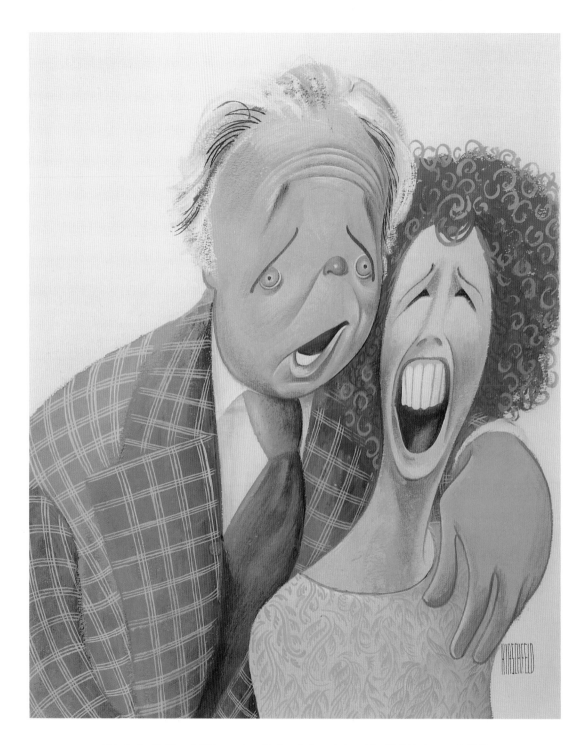

All in the Family (Carroll O'Connor, Jean Stapleton). Commissioned for *TV Guide*. January 6, 1979.
Gouache. Private collection

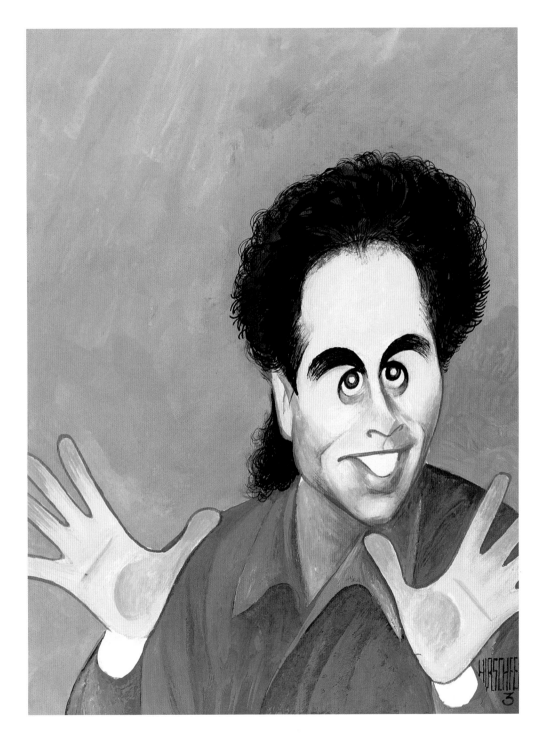

Jerry Seinfeld. Commisioned for *TV Guide*. March, 1998. Gouache. Private collection

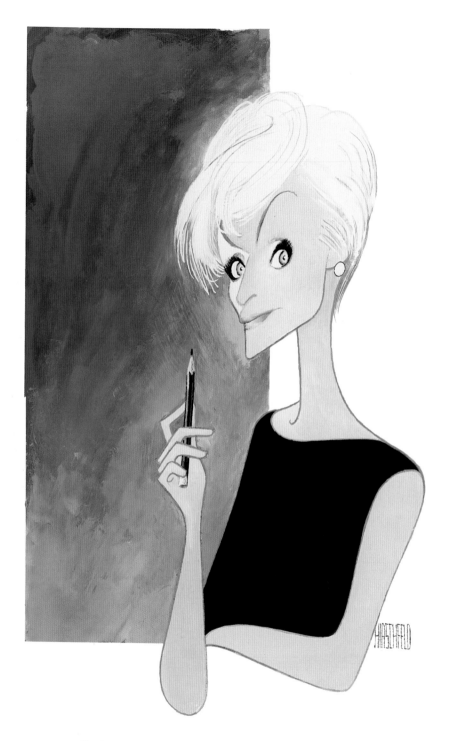

Tina Brown. Commissioned by *Talk*. 1999. Gouache. Private collection

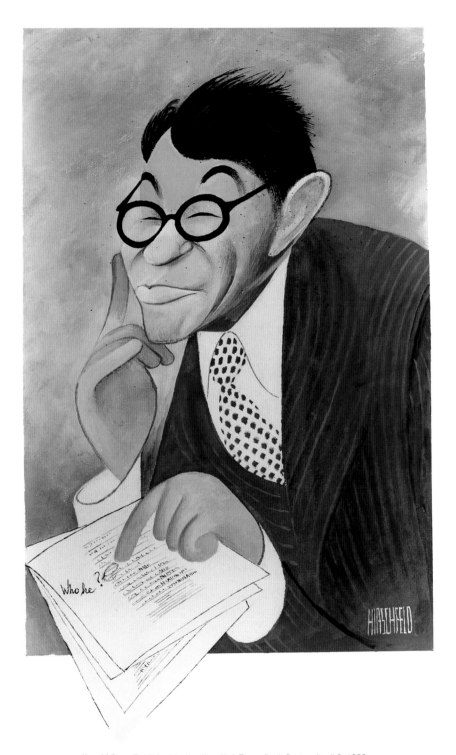

Harold Ross. Published in the *New York Times Book Review*. April 2, 1995.
Gouache. Harvard Theatre Collection, Houghton Library, gift of Melvin R. Seiden

Notes

1. Quoted in E. H. Gombrich and E. Kris, *Caricature* (Middlesex, England: The King Penguin Book, 1940), pp. 11-12.

2. Quoted in Rachel Chodorov, "Albert Hirschfeld" (New York: American Jewish Committee, Oral History Library, 1974). Interviewed on October 14, 1974, pp. 1-3. The interview is one of the most comprehensive discussions of Hirschfeld's earliest recollections of his family as well as his introduction to New York City.

3. Quoted in Walt Duka, "Broadway's Biggest Draw," in *AARP Bulletin* (Washington, D. C.) March 1999, vol. 40, no. 3, p. 26.

4. Quoted in *op. cit.*, pp. 1-4.

5. Quoted from David Levering Lewis, *When Harlem Was in Vogue*, (New York and Oxford: Oxford University Press, 1979, 1981), p. 184.

6. Hirschfeld has never shied away from caricaturing himself and can also be found cavorting with his contemporaries in the crowd in many of his drawings throughout the years.

7. A.K. Small, "Who's Who Abroad: Hirschfeld," *The Chicago Tribune* (April 24, 1926).

8. Quoted in Chodorov, p. 21.

9. Ibid., p. 23.

10. Ibid., p. 28.

11. Quoted in *The World of Hirschfeld* (New York: Harry N. Abrams, Inc., 1970), p. 16.

12. B. J. Kosposth, "A Painter and the Orient," *The Chicago Sunday Tribune* (Paris) (January 13, 1929).

13. Georges Bal, "Paris Art Notes," *The New York Herald* (Paris) (January 12, 1929).

14. Quoted in "Recalling Miguel Covarrubias" in Beverly J. Cox and Denna Jones Anderson, *Miguel Covarrubias Caricatures*, Exhib. Cat. (Washington, D. C.; Smithsonian Institution Press, 1985), p. 19.

15. "Young Men Landscape Their Pans to Deceive for Dignity and Biz," *Variety*, vol. XCVII, no. 2, October 23, 1929, p. 1.

16. Gordon Kahn, "A Gentleman's Guide to Bars and Beverages," in Al Hirschfeld, *Manhattan Oases, New York's 1932 Speak-Easies* (New York: E. P. Dutton & Co., Inc., 1932), p. 14.

17. Robert A. Caro, *The Power Broker: Robert Moses and the Fall of New York* (New York: Alfred A. Knopf, 1974), p. 455.

18. David Leopold in *In Line with Al Hirschfeld* (Katonah, New York: Katonah Museum of Art) Exhib. Cat. (January 18-April 5, 1998), p. 7.

19. William Saroyan in Al Hirschfeld, *Harlem as Seen by Hirschfeld* (New York: The Hyperion Press, 1941), n.p.

20. Al Hirschfeld, "Counter-Revolution in the Village," *The New York Times Magazine*, April 23, 1944, p. 16.

21. Ibid., p. 16.

22. Quoted in "An Artist Contests Mr. Disney," *The New York Times* (January 30, 1938), p. 4.

23. Quoted in Ronald L. Davis, "Al Hirschfeld," Southern Methodist University Oral History Program, Number 398. Interviewed on March 17, 1987, p. 35. Unpublished.

Index

Page numbers in *italics* refer to picture captions.

Algonquin Round Table, The, 58
Allen, Woody, 25, *86*
All in the Family, 90
Allyn, Florence, 17, *18,* 19, 23
American Ballet Theatre, 67
Annie Hall, 86
Apartment, The, 85
Armstrong, Louis, 69
Arthur Miller at Eighty, 76
Atkinson, Oriana, 56, 57
"Attention Green Tags, I'm Miss Savacool, your guide," 63

Benchley, Robert, *54, 58*
Bernstein, Leonard, 66, 68
Big City is Coming!, 27
Boys from Syracuse, The, 9, 24
Broadway First Nighters, 16, *60–61*
Broadway on a Saturday Night, 48
Brown, Tina, 92

Carnegie Hall Notables, 66
Case, Frank, *55, 58*
Colin, Margaret, 77
Composite of New York City Skyline, 36
Costello, Frank, 24, *51*
Counter-Revolution in the Village, 44
Covarrubias, Miguel, 16, *17,* 19, *19,* 20

Crowd at Gogi's Larue, The, 52

Davenport, Rodie, *19*
Dizzy Club Barman Jack, The, 29
Durante, Jimmy, *31*

Ellington, Duke, *71*

Ferber, Edna, 24, *54, 58*
First Night–Entr'acte (Covarrubias), 16, *17*
First Reading of The Man Who Came to Dinner, *The,* 79

Gershwin, George, *70*
Gibson, Charles Dana, 14

Goodman, Benny, 66, 70
Gould, Joe, 74
Greenwich Village Childhood, A, 56
Guitry, Sacha, 10, 18
Guys and Dolls, 24, 80

Haas, Dolly, 23, 61
Harlem as Seen by Hirschfeld, 22, 37, 38, 39
Harriman, Margaret Case, 24, 54, 55
Hart, Teddy, 24
Held, John, Jr., 14–15
Hirschfeld, Al, photographs of, 2, 12, 13
History of the Depression—Wall Street and
 Washington, 46
Horne, Lena, 68
House of the Lions, 57

Iceman Cometh, The, 81
In the Village They Imitate Stage and Movie Folk
 in Dress and Manner, 41

Jackie: An American Life, 77
Jerome Robbins' Broadway, 25, 88

Kahn, Gordon, 20, 20, 28, 29, 30
Kaufman, George S., 17, 24, 54, 58, 60
Kennedy, Dick, 19
Kerz, Louise, 11, 23
Koch, Ed, 87

La Guardia, Fiorello H., 20, 44, 50
Largely New York, 89
Lauder, Harry, 18, 21, 25
Laurel and Hardy, 15, 15
Lemmon, Jack, 25, 85, 86
Lenox Avenue Stroll, 38
Life With Father, 79
Life With Mother, 78
Lincoln, Abraham, 14
Little Greenwich Village Clubs Are Cheap and
 Informal and They Foster an Honest
 Cheerfulness, The, 43
Long Time No Sight-See, 62

Maney, Richard, 18, 73
Manhattan: A Sightseer's Somewhat Distorted
 View, 32
Manhattan and Me (Atkinson), 56, 57
Mansion Barman Eddie, The, 20, 30
Man Who Came to Dinner, The, 79
Martin, Mary, 11

Mike's Barman Ralph, 20, 28
Miller, Arthur, 25, 76
Monkey Bar at The Hotel Elysée, The, 53
Moses, Robert, 20, 44

New York as Seen by William Saroyan, 9, 23, 45
New York Drama Critics Circle, The, 59

Odd Couple, The, 86
O'Leary, 20, 30
O'Neill, Eugene, 25, 74
On Location Filming Young Doctors at Leone's
 Restaurant, New York City, 64
On the Town, 84

Papp, Joe, 25, 75
Parker, Dorothy, 55, 58
Perelman, S. J., 62, 63, 72
Prince, Hal, 76
Prisoner of Second Avenue, The, 85

Rent, 25, 89
Richard Maney: Lucubrations of a Press Agent,
 73
Ross, Harold, 31, 54, 93

Saroyan, William, 23
Save for the small fry, the candy store is practi-
 cally deserted, 40
Savo, Jimmy, 24
Seinfeld, Jerry, 91
Self-Portrait (in Barber Chair), 8
Selznick, David O., 14, 52
Selznick, Myron, 15, 15
Sharpy Family, 39
Short, Bobby, 71
Sightseers' Map of New York, 9, 34
Smith, Alfred, 20
Stage Door Canteen Reopens, The, 47
Steinberg, Saul, 9
Stompin' at the Savoy, 37
Strasberg, Lee, 77
Subway Drawing from Sardine Chauffeurs And
 Pushers In, 4–5
Sugar Hill Statesman, 37
Sunday in the Park—An Eccentric Map of
 Central Park, 35

Theatre Critics, 58
Tip of the Town, 57
Two for the Seesaw, 83

Upper West Side Intelligentsia Meet at Zabar's,
 The, 65

Van Vechten, Carl, 15–16, 17, 61
Vendor at 1939 New York World's Fair, 36
Vicious Circle, The (Harriman), 24, 54, 55

West Side Night Clubs, Everybody Is Frankly Out
 to Have a Good Time and Prices Are
 Reasonable, 42
West Side Story, 25, 82
What's the Matter with New York?, 23, 44
Wide Waste of Waters, 57

Photo Credits

Frontispiece courtesy Susan Dryfoos
Productions

Mr. Al Hirschfeld kindly provided photographs
for images on the following pages: 1, 12, 13,
14, 15, 18, 19, 20, 21, 27, 31, 32-33. 34, 35,
37, 38, 39, 44, 48–49, 50, 53, 54, 55, 56,
57, 58, 59, 60–61, 72, 74, 75, 81, 82, 85, 86,
89, 91, and 93

The Margo Feiden Galleries Ltd., New York
kindly provided photographs for images on the
following pages: 4–5, 8, 36, 40, 41, 42, 43, 44,
45, 46, 51, 52, 57, 62, 63, 64, 65, 66, 67, 68,
69, 70, 71, 73, 74, 76, 77, 80, 83, 84, 85, 87,
88, 89, 90, and 92

The Library of Congress kindly provided pho-
tographs for images on the following pages: 17,
and 47

The State Historical Society of Wisconsin
kindly provided photographs for images on
the following pages: 28, 29, and 30

Mr. George Goodstadt kindly provided the
photograph for images on the following page:
86

All other images are from The Museum of the
City of New York Collections and Archives

To my Darling Wife, Louise – Al Hirschfeld

Project Manager: Marti Malovany
Editors: Robert Morton, Justin McGuirk
Designer: Ellen Nygaard Ford

Library of Congress Cataloging-in-Publication Data

Bell, Clare.
 Hirschfeld's New York / text by Clare Bell ; introduction by
Frank Rich.
 p. cm.
Catalog of an exhibition held at the Museum of the City of New York.
Includes index.
 ISBN 0-8109-2974-0
1. Hirschfeld, Al—Exhibitions. 2. Manhattan (New York, N.Y.)—In
art—Exhibitions. 3. Broadway (New York, N.Y.)—In art—Exhibitions.
I. Hirschfeld, Al. II. Museum of the City of New York. III. Title.
 NC1429.H527 A4 2001
 741.5'973—dc21
 2001000634

Printed and bound in Hong Kong
10 9 8 7 6 5 4 3 2 1

Al Hirschfeld is represented by the Margo Feiden Galleries Ltd.,
New York

Harry N. Abrams, Inc.
100 Fifth Avenue
New York, N.Y. 10011
www.abramsbooks.com

1220 Fifth Avenue
New York, NY 10029
212.534.1672

Acknowledgments

There are few greater rewards for me, as a curator, than to have the
privilege of working with an artist whose talent is recognized the
world over and who has let me make myself at home with his studio
and archives. Al Hirschfeld is such an artist. While I researched, he
drew. Never once was Hirschfeld not drawing or about to draw
when I arrived. My times with Hirschfeld and his wife, Louise Kerz,
were marked by their generous hospitality and further enhanced by
their dedication to each other and their work. Without their aid and
support, this book would not be possible.

An expert on both Al Hirschfeld's work and the theater, David
Leopold deserves my utmost gratitude for helping me to navigate
through the artist's archives, steering me to remarkable pieces and
illuminating the stories behind them. Lynn Surry was another person
whose counsel on the project was invaluable. I would also like to
thank Margo Feiden and her staff for their assistance in helping me
to gather research and materials for the book.

A special note of gratitude to my colleagues at the Museum of the
City of New York especially Director Robert R. Macdonald, as well
as Peter Simmons, Kate Siplon, Kassy Wilson and Laura Mass for
their instrumental assistance and support. To the collectors of
Hirschfeld's New York City inspired work, I also owe a great debt of
thanks for allowing me to exhibit the works.

Hirschfeld's work on the American Theater is legendary; the same
can now be said of his work on the city, which inspires us all.

Clare Bell

Frontispiece: Al Hirschfeld

Page 1: **Judith Jamison in "The Only World in Town."**
Published in the *New York Times*. September 9, 1977.
Ink on board. Private collection